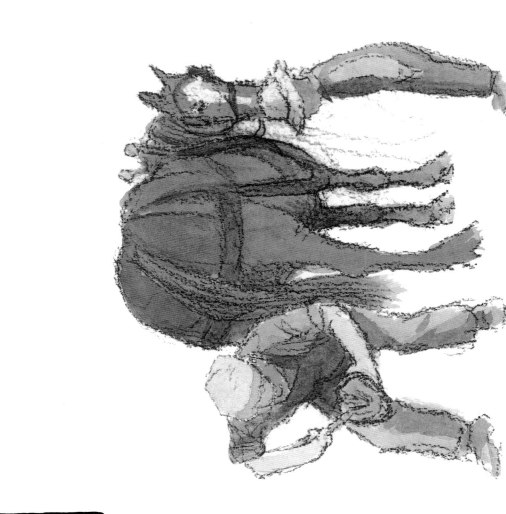

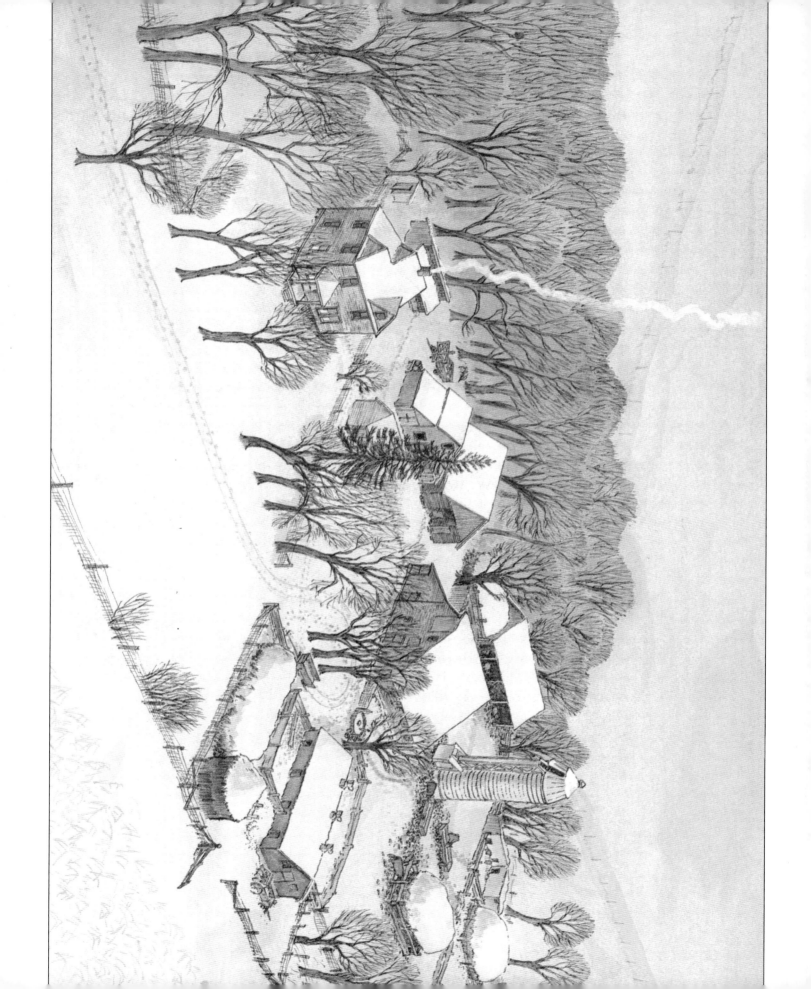

ONCE UPON A FARM

Written and illustrated by *Bob Artley*

Foreword by Paul Gruchow

PELICAN PUBLISHING COMPANY

Gretna 2001

This book is for all of those family members and friends to whom this farm has been a special place, particularly: Dean and his family, Dan and his family, and my children and their families; and to the memory of Ginny, Jeannie, Dad, Mom, Grandpa and Grandma Crow, and Grandma Artley and step-Grandpa Artley, all who helped to make this place what it is, and to Grandpa Amos Artley, who founded the farm with his dream in 1877.

First printing, August 2000
Second printing, March 2001

The word "Pelican" and the depiction of a pelican are trademarks of Pelican Publishing, Inc., and are registered in the U.S. Patent and Trademark Office.

Library of Congress Cataloging-in-Publication Data

Artley, Bob.
Once upon a farm / written and illustrated by Bob Artley ; foreword by Paul Gruchow.
 p. cm.
ISBN 1-56554-753-5 (alk. paper)
1. Farm life—Iowa—Hampton. 2. Artley, Bob. I. Title.

S521.5.I8 .A78 2000
630'.977728—dc21
[B]

00-026270

Printed in Hong Kong
Published by Pelican Publishing Company, Inc.
1000 Burmaster Street, Gretna, Louisiana 70053

CONTENTS

CONTENTS

FOREWORD

The odd notion has taken hold that because farm life early in this century was laborious, it was also mean and hard, an endless drudgery, a hellish burden to those who knew it. Partly this notion reflects the post-industrial doctrine that physical labor is inherently repulsive and that any avoidance of it serves the general good. Partly, too, it reflects the extreme sentimentalism with which we are wont to view contemporary life. If advancing technology really does make our lives ever and ever better, and will continue to do so for as long as we are technologically innovative—as post-industrial doctrine also holds—then it follows, as night follows day, that the past was unpleasant if not horrible, the present is the best time that ever was, and the future will increasingly approach the idyllic.

This idea is no more sensible or rational than the superstition that there was once, a long time ago, a Golden Age in which everybody and everything was perfectly happy and that life has been, ever since, steadily in decline. The Golden Agers now routinely get laughed out of the room, but the Life Was Never Better boys still command undeserved credence.

What is at stake here is the usefulness of the past. Is the past to be dead and gone, or is it to remain alive to us, as a set of signposts, as inspiration, as caution, as measure of who we are and what we have become?

Bob Artley's memoirs of farm life are precious precisely because they carefully avoid both the romance of the Golden Age and the romance of Progress, making available an account of the past that, because it is clear-eyed, is still usable. Artley's story includes both the smell of new-mown hay and the stench of manure, the taste of fresh cream on strawberries and the tedi-

um of washing the separator parts, the dust and din of threshing and the neighborliness of it. His is neither an ideal world nor an outmoded world, but simply the world as it was in a particular time and place, in a portrait offered with affection but without favoritism or prejudice.

As it happens, we now know, the world that Artley experienced as a boy—and about which he seems to have forgotten absolutely nothing—was one that was, even then, nearly at an end in the industrialized West. With its collapse came the demise of an agrarian culture that had been 10,000 years in the making, a culture that had given rise to the dominant religious traditions of the United States and to the political ideals upon which it was founded.

Cultures, like all mortal creations, live and die, but this does not mean that, when they have died, they must be forgotten or may be forgotten with impunity. Plato's metaphor of the cave and the logic of Aristotle still have their vital uses, even though the ancient cultures of the Greeks and Romans have long since vanished.

Yeoman farm culture—the one that Artley here describes—has recently gone the way of the Greek and Roman civilizations, but its highest ideals—however rarely they were realized in fact—of independence, of self-sufficiency, of thrift, of neighborliness, of good stewardship toward all creation—the ideals Artley here so subtly and powerfully evokes—will remain worthy to the end of time.

PAUL GRUCHOW
Author, lecturer, editor, teacher
and environmentalist

ACKNOWLEDGMENTS

ACKNOWLEDGMENTS

Almost all of these illustrations, watercolors, and line drawings are recycled. Most of the color illustrations first appeared in the *Worthington* (Minnesota) *Daily Globe* in feature articles and a weekly half-page series under the title "Once Upon a Farm." Several other color illustrations first appeared in a monthly half-page feature in the *Agri News* of Rochester, Minnesota, entitled "Of Earth and Season."

Three of the watercolors first appeared in two issues of *Christmas: The Annual of Literature and Art,* published by Augsburg Publishing House and Augsburg Fortress, then republished by Iowa State University Press in a book titled *Country Christmas, as Remembered by a Former Kid.*

Three additional watercolors were made expressly for this book.

The line drawings are taken from those I did for books published by Iowa State University Press, spanning the years 1978 to 1996, and from syndicated cartoons from Mugwump marketing.

The text is all new, appearing for the first time in this book, *Once Upon a Farm.*

I want to thank all of the above publishers for permission to reuse the color and line illustrations in the production of this book.

I also want to thank the many individuals whose help in many different ways has been so vital in making this book possible, including the staff of Pelican Publishing Company, Paul Gruchow, my family, and most certainly, my wife, Margaret, without whose help and encouragement this book would not have been.

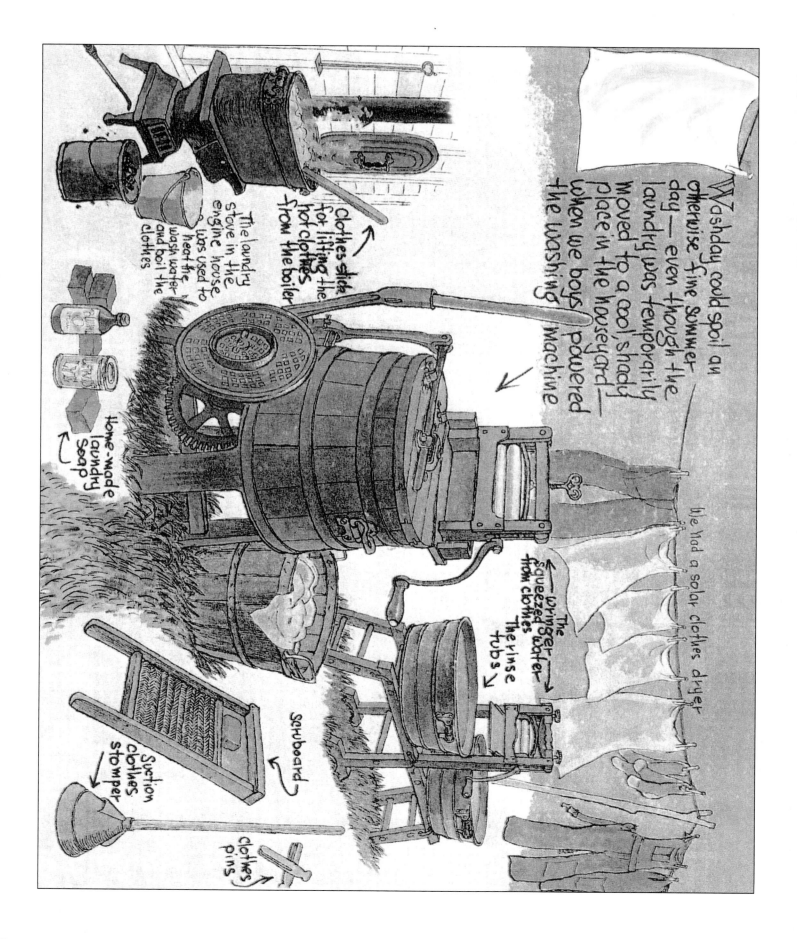

Washday could spoil an otherwise fine summer day — even though the laundry was temporarily moved to a cool, shady place in the houseyard — when we boys powered the washing machine

We had a solar clothes dryer

Clothes stick for lifting the hot clothes from the boiler

The laundry stove in the engine house was used to heat the wash water and boil the clothes

Home-made laundry soap

The wringer squeezed water from clothes

The rinse tubs

Scrubboard

Suction clothes stomper

Clothes pins

PREFACE

Wash day, when I was a boy on the farm, was not one of my favorite times. However, in the summer, when the hand-powered washing machine, rinse tubs, and wringer were set up in the deep green grass in our house yard under the shade of the towering spruce trees, the chore of helping our mother with the family laundry was not unpleasant. Under a deep blue sky, with white fluffy clouds moved along by a gentle breeze, powering the wooden washer and cranking the clothes wringer could be much more pleasant than hoeing out thistles in a hot corn field.

Although Mom was never published, she did write a lot. She had a widespread correspondence with her far-flung family and friends and for years kept journals of the life and times of our family farm, which is a treasured legacy for her descendants. She also tried her hand at poetry.

Not only was my mother a prodigious letter writer and journalist, she was also a voracious reader of books. She kept abreast of national and world news through current newspapers and periodicals. Very well read, she had much to share from the world of books and ideas during our washday visits.

While I cranked the wringer and she fed the washed clothes through the rollers from one tub of rinse water into the other, we were able to engage in some of our best conversations, making these wash day visits some of my most cherished memories. It was here that Mom bolstered my dreams for my future. We talked of books and ideas, and I was encouraged to pursue and develop my drawing talent and aspirations to be a cartoonist. And it was here that she expressed the hope I, through my work, could somehow show the good side of farm life and of those who worked the soil.

In the early 1950s, when I was again trying to complete my college education, after time out, first for World War II and then for a brief stint of farming the home place, I left the farm and pursued studies that led me farther away from that life. Nevertheless, my heart was still nurturing my love for the farm. It was during this period that the seed was planted for this book.

As an art student at the University of Iowa, I was taking a class under the renowned artist and print maker, Mauricio Lasanski, known especially for his beautiful copper engravings. While working at the demanding art of engraving on copper, I dreamed of producing a portfolio of prints depicting farm life as I had known it. But due to financial troubles, my art studies at the university were terminated and my dream had to be put on hold.

Years later, as editorial cartoonist for the *Worthington* (Minnesota) *Daily Globe*, I started submitting watercolors and essays with a farm theme. These color contributions evolved into a weekly feature, "Once Upon a Farm," which appeared as a half-page, full-color spread.

So it is that this book, *Once Upon a Farm*, a view of our family's farm where I grew up, now appears as a descendant of that newspaper feature by the same name. It is an accumulation of much baggage from over the years . . . all with the distinct aroma of the farm.

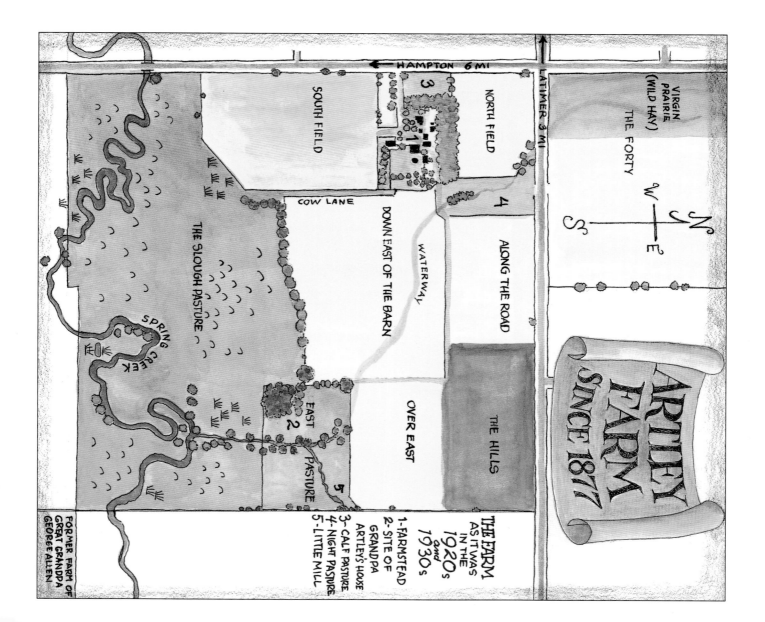

ARTLEY FARM SINCE 1877

VIRGIN PRAIRIE (WILD HAY)

THE FORTY

LATIMER 3 MI

← HAMPTON 6 MI

NORTH FIELD

SOUTH FIELD

COW LANE

DOWN EAST OF THE BARN

WATERWAY

ALONG THE ROAD

OVER EAST

THE HILLS

THE SLOUGH PASTURE

SPRING CREEK

EAST PASTURE

THE FARM AS IT WAS IN THE 1920s and 1930s

1- FARMSTEAD
2- SITE OF GRANDPA ARTLEY'S HOUSE
3- CALF PASTURE
4- NIGHT PASTURE
5- LITTLE MILL

FORMER FARM OF GREAT GRANDPA GEORGE ALLEN

PROLOGUE

PROLOGUE

Time and the seasons have brought many changes to this place I have come home to all of my life. And, of course, the seasons and the years ahead will bring many more. Change is the one constant we can count on.

According to a penciled note in an old pocket notebook of Dad's that was recently discovered, my young parents moved to what is now known as Artley Farm in April of 1917. They moved there, with the help of friends and family, on muddy spring roads in horse-pulled wagons loaded with household goods, farmyard tools, implements, and a buggy. The buggy, with the bay driving horse, Dick, was driven by my mother, Elsie, who was six months pregnant with me.

They had moved from what was considered by the family to be a "secure" situation on the family farm on the east edge of Hampton, Iowa, to this "lonely" place six miles away to the west of town, which was my father George's inheritance.

In the face of strong opposition from my grandmother, Frances Artley (who never quite forgave them for moving away), my parents were nevertheless determined to make their own life on their own farm, regardless of the hardship and bad feelings that lay ahead.

Dad's father, Amos, had purchased the 162 acres in 1877 from a Civil War veteran who had been granted the land by the government. Shortly thereafter he acquired 40 more acres across the road, north of the rest of the farm.

Within the next few years, he set about making it his own. Being unmarried, he built a small two-room, two-story house on a low knoll near a willow-lined small stream that emptied into a larger stream, Spring Creek, several rods to the south. He also erected a shed for the cattle that grazed the hills and lowlands of his farm.

Not adjoining his land but "touching" it at the corner where the section was divided into quarters was the farm of his neighbor and partner in the cattle business, George Allen, a Civil War veteran who had been captured by the Confederate army and spent several harrowing months in the infamous Andersonville prison. Subsequently, the discharged Union soldier had married and moved to the farm kitty-cornered from Amos's farm in section twenty-six of Marion Township in Franklin County, Iowa.

It was through their close relationship in their cattle venture that Amos became interested in his partner's daughter, Frances. In spite of her being twenty years younger than Amos, they were married and moved to the farm home on the east edge of Hampton. (Amos didn't think his little house by the willows was a fit place to take his bride.)

Sometime between 1877 and 1891, when my father, George Dennison Artley, was born to the couple, Amos planted a large grove of trees on a knoll near the northwest corner of his newly purchased land. This grove, where some of the original trees of ash, maple, cottonwood, box elder, walnut, butternut, and Norway spruce still stand, became the building site of the present farm.

However, Amos was not to see the development of the pleasant homesite he had chosen. When his small son, George, was only three years old, Amos died suddenly from a hemorrhaging stomach ulcer, leaving a widow and her two small children, George and his older sister, Nina. Amos's younger brother, George P. Artley, then came to the rescue of the grieving young family and became Frances's second husband. He was the only father Dad ever knew, and lovingly referred to his namesake as "Pa." He became the father of Ruth and Wayne, young George's and Nina's half sister and brother.

George (Pa) died in his sleep on a winter night in 1916, shortly before my parents were to be married, making Frances a widow, once again.

But while he was still living, "Pa" and "Ma" developed the

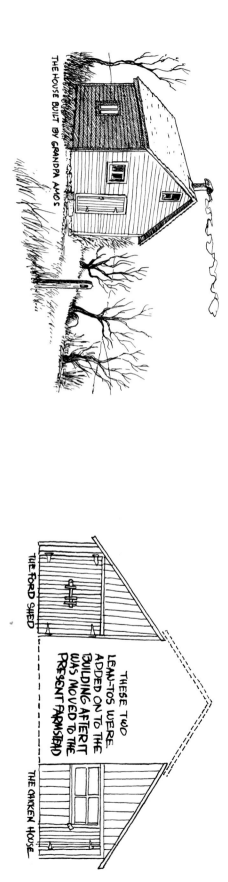

THE HOUSE BUILT BY GRANDPA AMOS

THE FORD SHED

THESE TWO LEAN-TOS WERE ADDED ON TO THE BUILDING AFTER IT WAS MOVED TO THE PRESENT FARMSTEAD

THE CHICKEN HOUSE

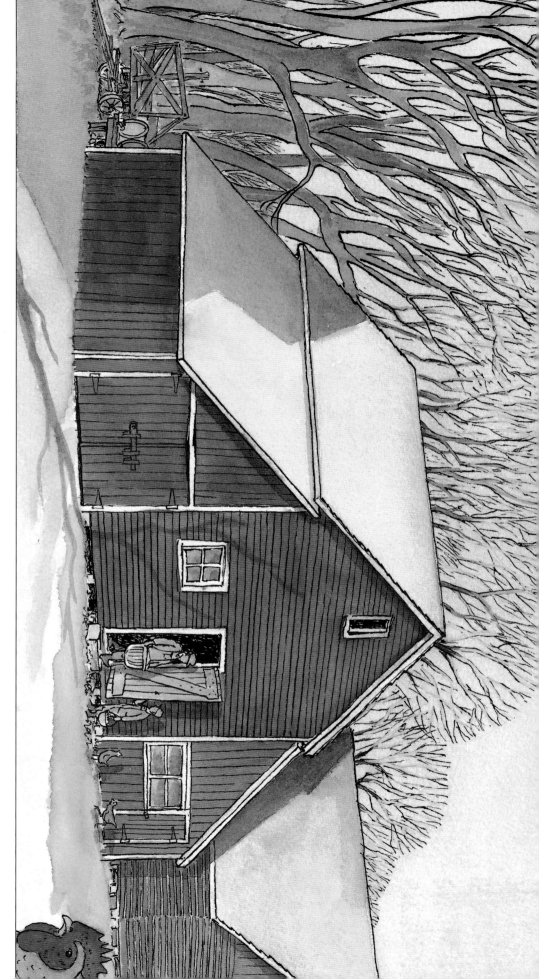

farm homesite Amos had started with his grove. They made a clearing in a thick stand of trees and built the horse barn, with its oat bin, haymow, and stalls for twelve horses. Later a lean-to was added to the north side of the barn, with stanchions for milk cows.

They also had the little house and cattle shed Amos built at the willows moved to the new building site. Then in 1910, a two-story, eight-room house was built, along with a double corn-crib and a privy. Amos's little house became a granary with a lean-to on each side, one as a place for chickens and the other as a garage, or as we knew it, the "Ford shed." A sixty-foot well was added to the young farmstead, which still serves today. Even during the drought of the 1930s it never failed, providing clean, cool, potable water for the humans and animals of the farm.

Next to the well was constructed a shed that has served variously as a place for the one-cylinder Mogul gasoline engine that provided power for the pumpjack that drew water for the stock tank, a summer place for the cream separator, with a water tank for keeping the cream cans cool, a wash house with a little coal stove to heat water for the laundry tubs, and a summertime place to bathe. Currently the restored building serves as a farm workshop.

With the farm thus established, and Dad too young to take over, the place was rented to neighbors close by and then, after the house was built, to tenants.

It was only after my father had finished his course in animal husbandry at the Iowa State College at Ames (now known as Iowa State University), and his marriage to my mother, that the impetus toward having their own place, set back for about a year due to the death of Pa, became a reality.

After my parents moved to the farm, their first improvement was a cypress wood stave silo built in 1919.

The homestead, with the above-mentioned buildings, was what I gradually became aware of and came to know intimately through the years.

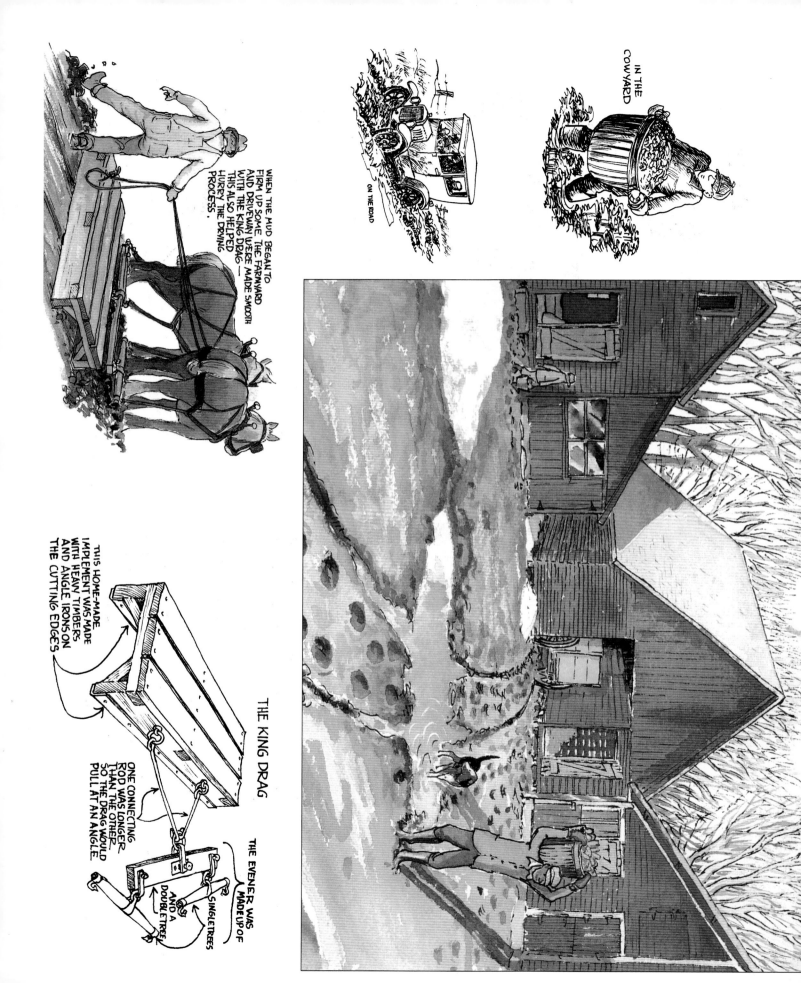

WHEN THE MUD BEGAN TO FIRM UP SOME, THE FARMYARD AND DRIVEWAY WERE MADE SMOOTH WITH THE KING DRAG — THIS ALSO HELPED HURRY THE DRYING PROCESS.

ON THE ROAD

IN THE COWYARD

THE KING DRAG

THIS HOME-MADE IMPLEMENT WAS MADE WITH HEAVY TIMBERS AND ANGLE IRONS ON THE CUTTING EDGES

ONE CONNECTING ROD WAS LONGER THAN THE OTHER, SO THE DRAG WOULD PULL AT AN ANGLE

THE EVENER WAS MADE UP OF SINGLETREES AND A DOUBLETREE

SPRING

MUD ... FROST ... HOPE

Early spring, with its mud and mess, brought alternating hope and despair. Mild, sunny days of soft southerly breezes could change within a few hours to cold, blustery winds and even late-season snowstorms.

How our spirits were dampened when we awakened on an early spring morning to see the landscape smothered in a blanket of fresh snow! Only the evening before the beams of the setting sun had shown their red glow on the remnants of the shrinking snow banks of winter and across patches of dry ground, here and there, around the farmyard. Now, with the new snow, we faced a setback to more cold wet/muddy days ahead. The swelling buds on the trees, coated with sleet, could be broken off by the wind and fall to the ground, delaying even further the emergence of leaves and blossoms. Crocuses, tulips, and other early emerging plants, and our hopes for "normal" spring weather, were literally nipped in the bud. And, without the trauma of a late snow or sleet storm, a late-season frost could cause the same damage and setback to the greening and blooming of the farm.

Thankfully, the grass seemed immune to these early-spring, late-winter onslaughts, and with only a few days of warm sunshine, all seemed forgiven and the lawns and pastures were burgeoning with luxuriant new growth. The cattle, still within the confines of the muddy barnyard, stood at the south fence, breathing in the fragrance of a greening pasture wafted on the southerly breezes, no doubt whetting their appetites for a change of diet from their winter fare of silage and dry fodder.

As the season progressed (and retreated), and we struggled with our faith in the renewal of life, the frosty nights and blustery cold, northerly snow-laden gales gave way to lengthening days of warm sunlight and gentle warm breezes with the fragrances of the warm, damp fields and greening sod.

The first of the migrating birds began to return, with great flocks of blackbirds that gathered in the budding bare branches of the groves. These exuberant early arrivals warbled their cacophonous concerts to the new season. Then, little by little, the other birds appeared, some only passing through to more northerly destinations. Of these, the most spectacular were the Canada geese, "honkers," that we sometimes heard before spotting them as they winged their way northward in great noisy "V" formations.

The killdeer, song sparrows, meadowlarks, turtle (or mourning) doves, finches, and house wrens gradually made their welcome presence known by their familiar songs. The barn swallows took up their summer homes in the barns and open sheds, neighbors to the year-around sparrows, who, with their noisy chirping, along with the quiet cooing of pigeons in the hayloft, helped keep the farm alive and friendly through the cold winter months.

To spot the return of the first robin of the season was somewhat of an unofficial contest as neighbors vied to be the first to report sighting this ubiquitous bird, which seemed to make the arrival of spring official.

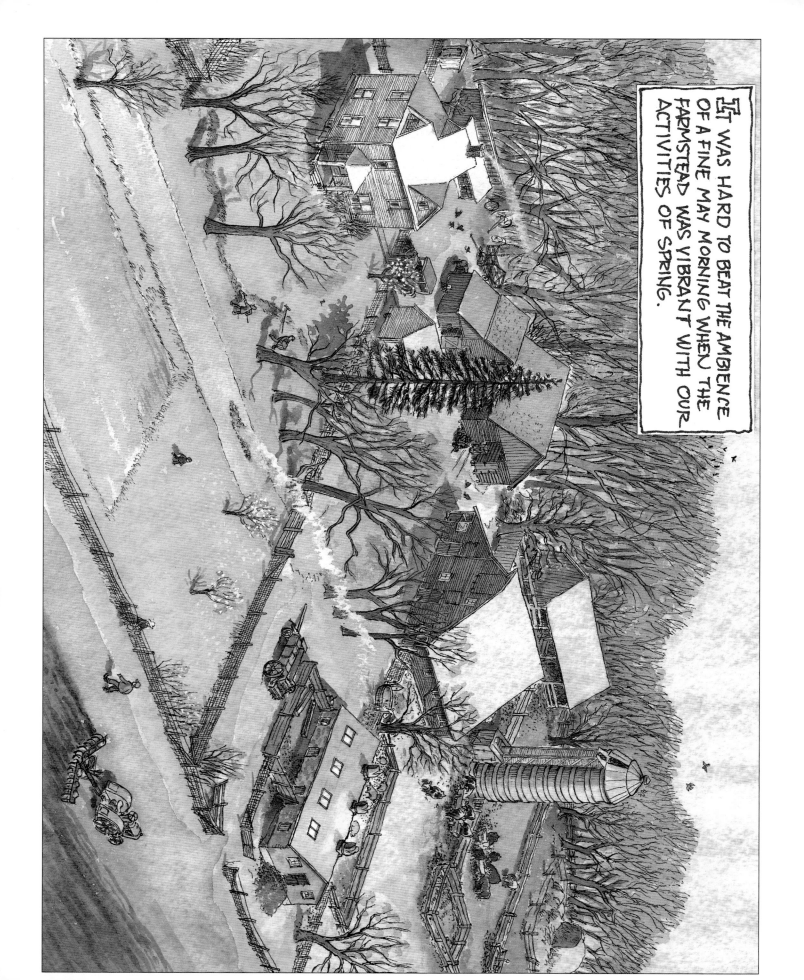

IT WAS HARD TO BEAT THE AMBIENCE OF A FINE MAY MORNING WHEN THE FARMSTEAD WAS VIBRANT WITH OUR ACTIVITIES OF SPRING.

SPRING IN ALL ITS GLORY

When the weather finally settled down and spring appeared to have decided to stay, the farm was never fairer. The sun-warmed air was fresh and easy to breathe, and the moist earth was fragrant with odors of new life. The songs of the birds echoed the song in our hearts as we celebrated, finally, the end of winter.

We were happy in our spring chores of raking the yard and making a bonfire of the trash. Potatoes were planted, tradition-ally, on Good Friday, or as near to that time as possible, weath-er permitting. As a result of the spring floods and ice flows, we repaired the creek fences and turned the cattle out to pasture.

It was a joyful time, the day we first took them to pasture, not only for the cattle but for us too. They showed their obvious joy as they eagerly surged through the opened gate and kicked up their heels, wading knee-deep into the lush, green grass, grab-bing a mouthful as they hurried on to explore the expanse of their new freedom. In a short while they had traveled the cir-cumference of their summer domain, sampling the new menu they had been sniffing on the air in recent days. When we brought the milk cows up that first evening, they seemed tired

but happy, and the next morning, after milking, eager to return to pasture.

These halcyon days of spring were punctuated by warm spring showers. The violets, dandelions, and other wild flowers burst forth in all their glory, as did the apple and wild plum blossoms, adding their fragrance to the air. It was the wild plum trees, hav-ing been inadvertently planted by birds along the fencerows, which were an especially enjoyed fragrance as we walked back and forth to school on those spring days. And, speaking of school, we anticipated the school picnic and the last day of school, when we, like the cattle, would be turned out to pasture for the summer.

Of course, springtime also brought thunderstorms. While we were told that lightning produced nitrogen for our crops, we nevertheless didn't always appreciate the way it was delivered, especially when a strike was nearby. Some of these spring storms spawned tornadoes, which were a constant concern—especially at night when we could not see the predator cloud. But when the dripping dawn came and our farm shown intact in the bright sunlight, we again rejoiced in the miracle of spring.

A SPRING RITUAL— WHEN GRANDPA TOOK TIME FROM PLANTING THE GARDEN TO MAKE US WILLOW WHISTLES.

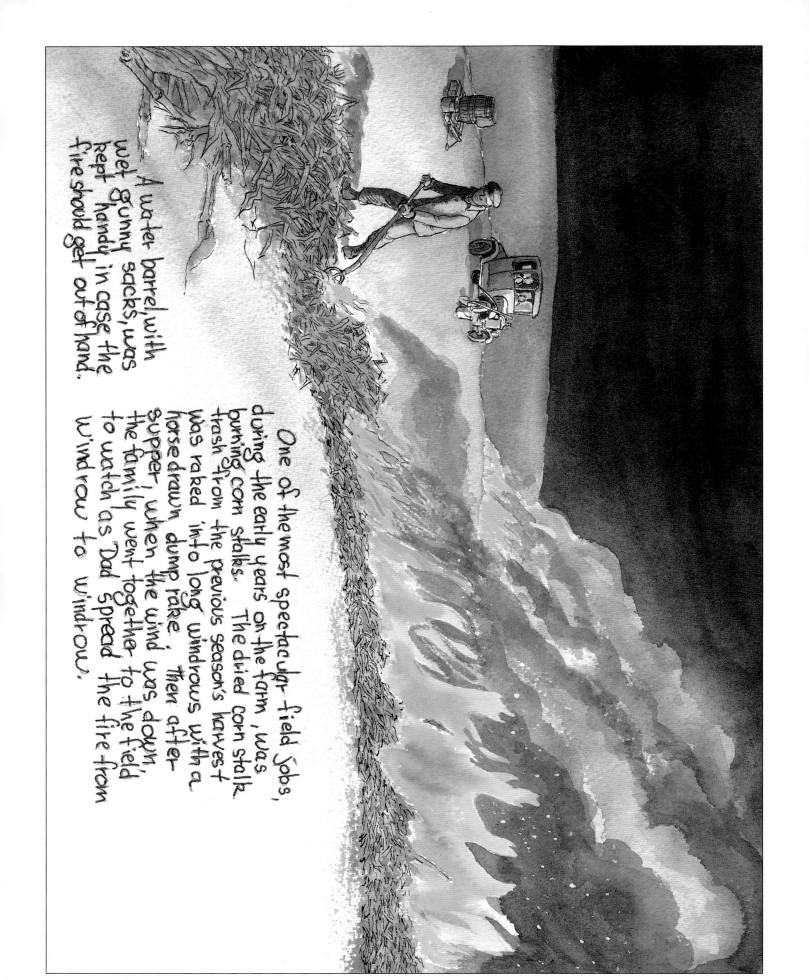

One of the most spectacular field jobs, during the early years on the farm, was burning corn stalks. The dried corn stalk trash from the previous season's harvest was raked into long windrows with a horsedrawn dump rake. Then after supper, when the wind was down, the family went together to the field to watch as Dad spread the fire from windrow to windrow.

A water barrel, with wet gunny sacks, was kept handy, in case the fire should get out of hand.

CLEARING THE FIELDS

In late March or early April, as soon as the ground became firm and dry enough to work, farmers all around the neighborhood took to the fields. Oats were the first crop to be planted. Quite often the field of last season's dry corn stalks, still standing, were broken down with the disc. Then this dry residue was raked into long windrows and at night, when there was no wind, they were set afire and burned to clear the fields of trash. The spring night skies were made dramatically colorful by these controlled fires around the neighborhood, as farmers cleared the fields for oat seeding and at the same time destroyed the dormant stage of the dreaded corn borer that wintered over in the dry stalks. This method of clearing the fields, however, was soon abandoned when it was realized that the residue, when worked into the soil, provided a nutrient and helped prevent wind erosion.

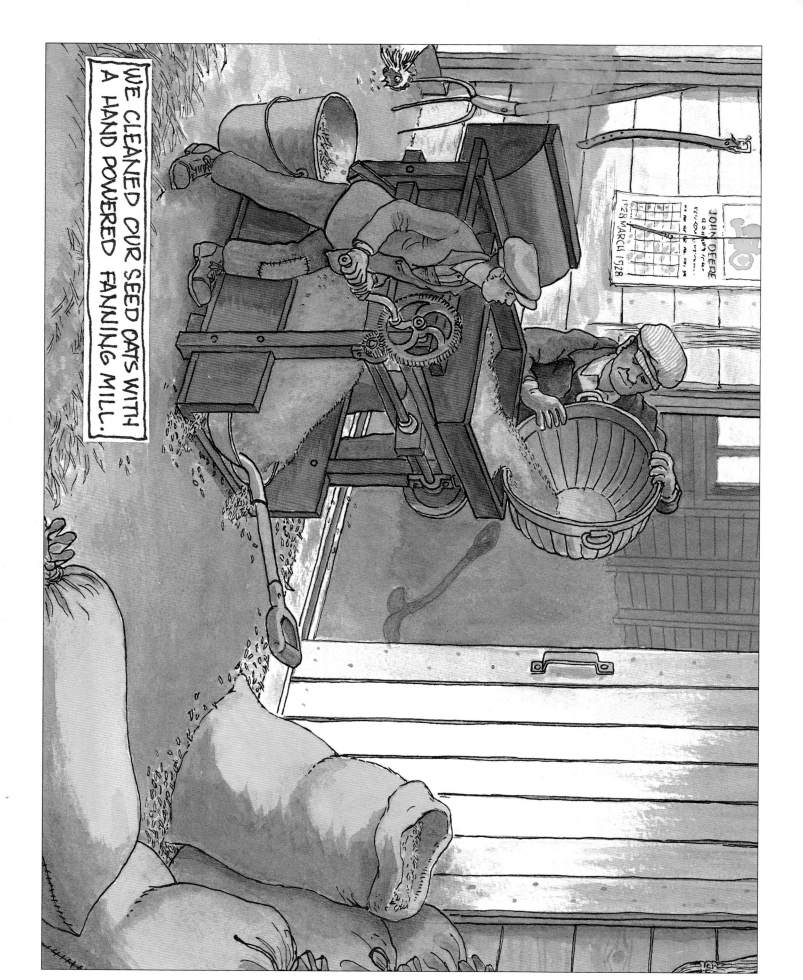

WE CLEANED OUR SEED OATS WITH A HAND POWERED FANNING MILL.

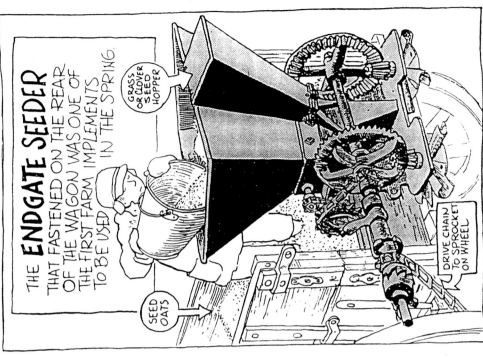

SEEDING OATS

The seed oats, taken from the previous season's store in the oat bin in the barn, were cleared of dirt and weed seeds by a hand-cranked winnowing machine. The endgate seeder was attached to the back end of the wagon loaded with seed oats, and as it was driven back and forth across the field, the chain-driven seeder cast the seed in a wide swath. Often clover and timothy was seeded in with the oats to provide a crop of hay for the following year.

The clover seed had been previously mixed with a nitrogen-fixing inoculant. On the oat seeder, alongside the large hopper into which we shoveled the seed oats from the wagon, was a smaller hopper for the clover seed, which was metered out with the oats as it was being sown.

After the seed had been sown on the field, previously cleared of the past year's debris, the ground was pulverized by a horse-drawn disc. This discing process, usually consisting of crisscrossing the field two or more times, loosened the soil and worked the sown seed into it.

Finally, the oat seeding work was completed by two or more passes with the spike-toothed harrow, again crisscrossing the field, until the seed bed was smoothed and the seeds were left to spring to life. With warm spring showers and sunny days, it wasn't long before the black loamy field took on a misty green hue as the seed germinated and emerged.

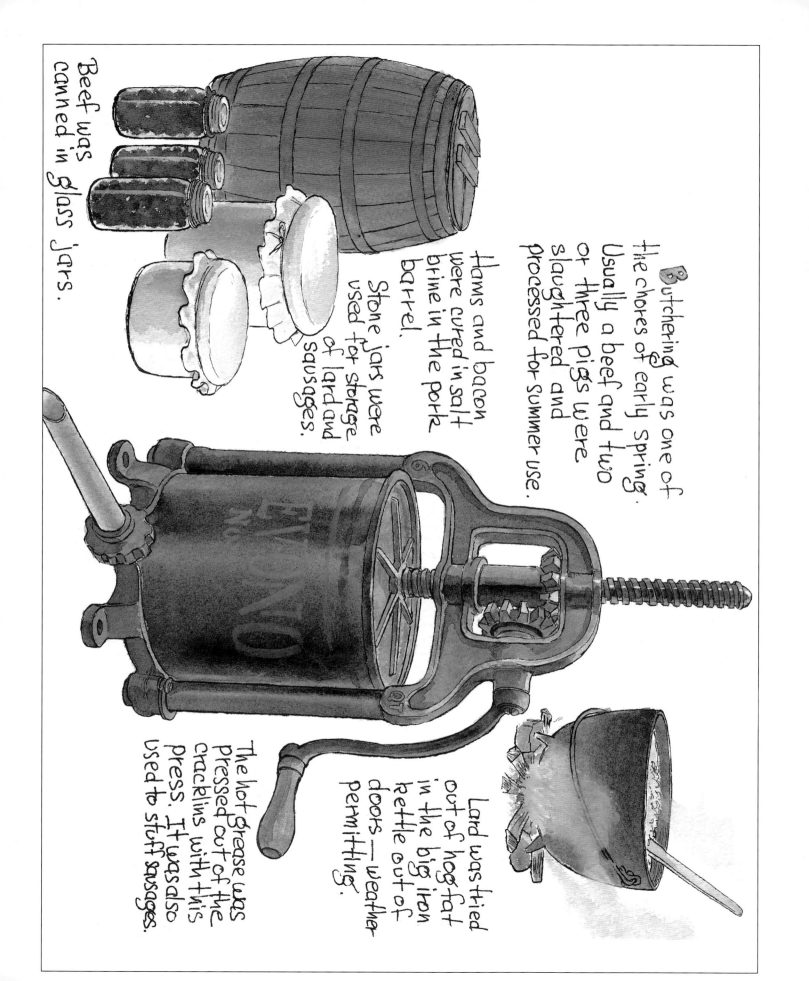

Beef was canned in glass jars.

Butchering was one of the chores of early spring. Usually a beef and two or three pigs were slaughtered and processed for summer use.

Hams and bacon were cured in salt brine in the pork barrel.

Stone jars were used for storage of lard and sausages.

Lard was tried out of hog fat in the big iron kettle out of doors—weather permitting.

The hot grease was pressed out of the cracklins with this press. It was also used to stuff sausages.

BUTCHERING

Our farm was largely self-sustaining. We grew most of the food we ate, with the exception of flour, sugar, coffee, tea, the spices and extracts used in cooking, and some other groceries that we traded for. Meat products, with few exceptions, came from our own farm. Homegrown pork, beef, and chicken were butchered for the meat in our diet. Chickens, usually surplus roasters or old hens, were killed as needed for fried chicken dinners, roasts, soups, or pot pies. Dad did the killing and plucking, and Mom dressed them (to me it seemed she undressed them), then cut them into manageable pieces for cooking.

Our pork and beef supply was done differently. Usually in early winter, a steer or a hog or both was butchered for fresh meat supply during the winter. With subfreezing weather there was not much of a problem keeping the butchered meat fresh. Sometimes a carcass would be covered with a cloth and hung from a beam in the alleyway in the corncrib out of reach of dogs or other meat-eating creatures. When a steak of a pork chop or some other choice cut of meat was wanted, it was sliced from the hanging frozen carcass. Soon the kitchen would be fragrant with the smell of beefsteak or pork tenderloin frying in an iron skillet on top of the range.

A smell in the kitchen that was not pleasant, however, was that of lard being rendered out in an iron kettle, also on the stovetop. At the time of butchering, the layers of fat under the pig's skin were cut into one-inch cubes and put into the kettle to cook until the fat became liquid. This hot liquid fat was strained through a muslin cloth into stoneware crocks to cool, becoming white lard. This lard was used as shortening for cooking and baking.

Early spring was another butchering session, when another cow and maybe two or three pigs would be slaughtered. This was for our summer's meat supply. The beef was cut up into one-inch chunks and put into sterile glass jars, seasoned with salt and

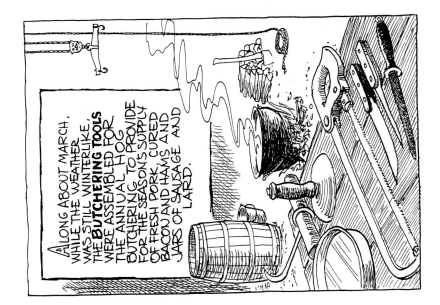

pepper, and boiled in a hot-water bath until the meat was thoroughly cooked. After these sealed jars were allowed to cool they were stored on shelves in the cellar. Many summer noontimes we would come in from the fields to be served a delicious beef dinner Mom had produced from one of the glass jars of canned beef.

The pork was usually processed into smoked hams, shoulders, and side meat (bacon). Much of the other meat was ground, mixed with spices and herbs, and made into sausage patties or stuffed into cleaned pig intestines and made into links.

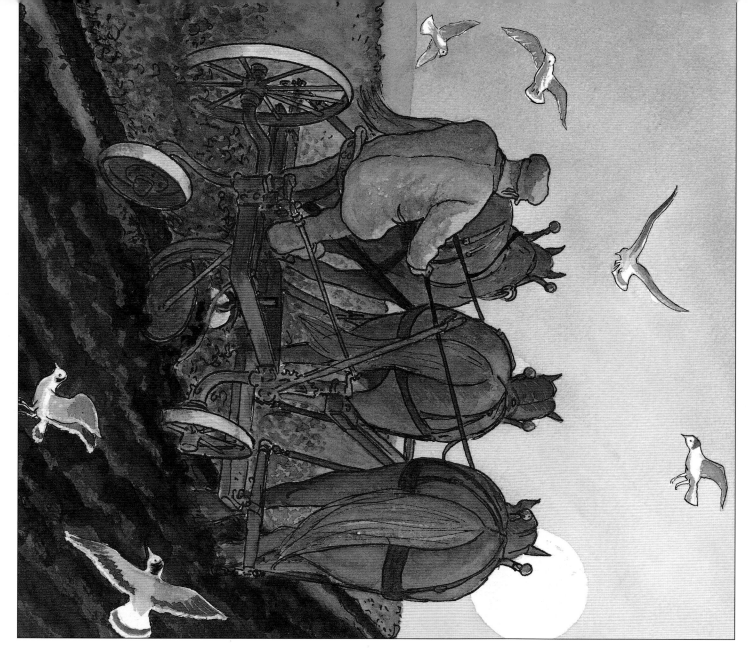

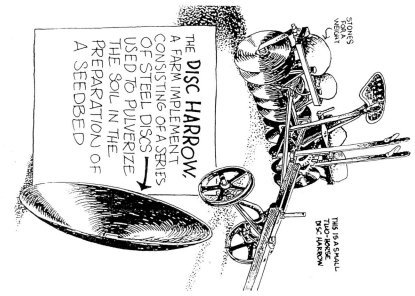

THE **DISC HARROW:**
A FARM IMPLEMENT
CONSISTING OF A SERIES
OF STEEL DISCS
USED TO PULVERIZE
THE SOIL IN THE
PREPARATION OF
A SEEDBED

STONES
FOR A
WEIGHT

THIS IS A SMALL
TWO-HORSE
DISC HARROW

PLOWING WITH HORSES

With the oat crop in and clover seeded, attention was turned to preparing the fields for the corn crop. Oat stubble or hay ground that had not been plowed the previous fall was turned with a moldboard plow. In the early years of the farm, plowing was done using a single or gang, horse-drawn sulky plow.

As the three or four-horse hitch, with the plowman perched on a stamped-iron seat, holding the reins to the horses, turned the land, the quiet sounds of the plodding horses, the creaking and clanking of the harness, pebbles scraping the steel moldboard, and an occasional word of encouragement or reprimand from the teamster were all that could be heard in this cocoon of silence moving slowly across the field. Beyond the subdued sounds of team and plow could be heard the song of the meadowlarks, the frantic call of the killdeer, and the wind whispering in the grass on the headlands. These quiet natural sounds experienced by man and beast, when farming with horses, were lost when we went to tractor power.

Sometimes, quite often, in fact, stones left over from the debris deposited by the great glacier of the last ice age were turned with the soil. Those that were only large pebbles or fist-sized stones posed no problem, but all too often the steel plow-share would strike a boulder the size of a man's head, or larger. These sudden, unexpected encounters caused the plow to lurch violently, and the plowman would be thrown from his precarious perch on the iron seat as the plow and horses were brought to a jolting halt. This collision with a piece of prehistoric debris shattered the peaceful ambience of the bucolic scene. The songs of the birds and the sound of the wind in the grasses were interrupted by the expletives of the hapless plowman as he rubbed his bruised shin and examined the extent of damage to the plow.

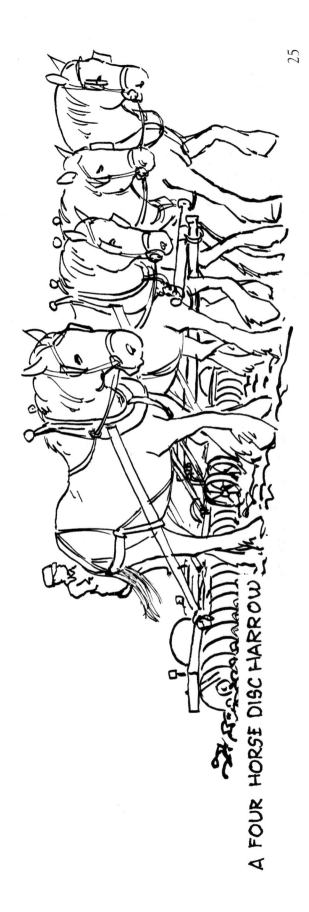

A FOUR HORSE DISC HARROW

The Fordson was the first tractor on our farm. It replaced horses only on the heaviest of the work — plowing and discing.

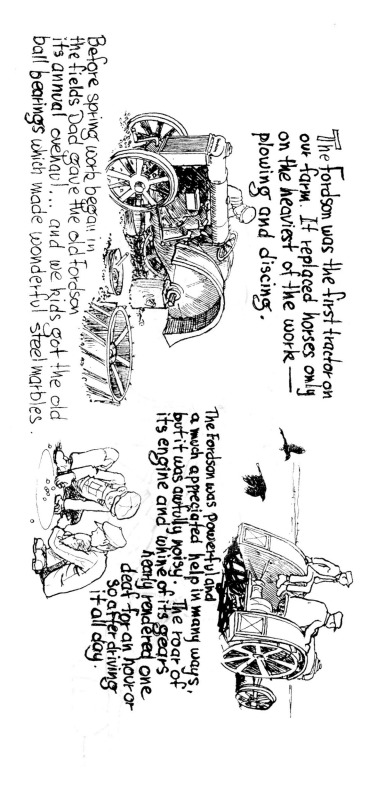

The Fordson was powerful and a much appreciated help in many ways, but it was awfully noisy. The roar of its engine and whine of its gears nearly rendered one deaf for an hour or so after driving it all day.

Before spring work began in the fields Dad gave the old Fordson its annual overhaul ... and we kids got the old ball bearings which made wonderful steel marbles.

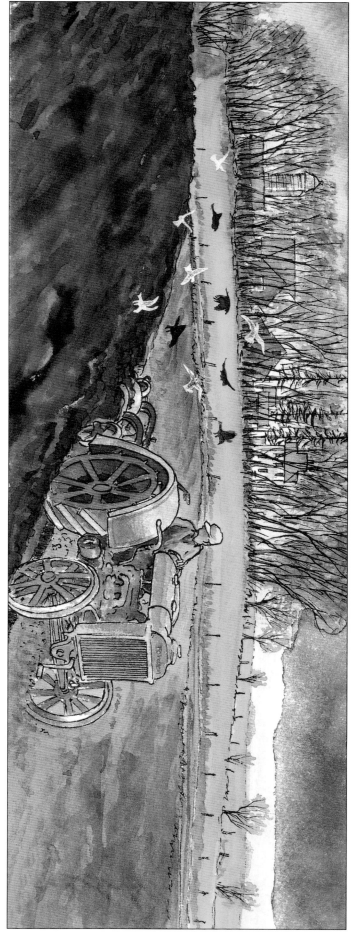

TRACTOR POWER

In the mid-1920s, Dad bought a Fordson tractor. With this new power source we were able to plow and disc faster and put in longer days than was possible with the limited endurance of horses. However, fieldwork would never be the same; something very good was gone. With the deafening roar of the powerful engine and the howl of the gears, all the quiet, natural sounds of the field were drowned out. And the exhaust fumes and the smell of the hot grease of the engine smothered the sweet odor of the crushed grasses and the moist, rich soil, as the steel moldboard turned it and laid it in neat ribbons across the plowed field, exposing a fresh furrow with every round.

On the two-bottom tractor plow, the hitch was connected with a wooden peg, which would break and give way when the plow hit a rock, thus preventing a sprung frame and limiting the damage to the plowshare. These encounters with rocks, some of which were actually the tips of large boulders, entailed an interruption of the spring work. The offending stone had to be dug out and hauled away to the rock pile at the edge of the grove. This meant hours, sometimes, prying with a crowbar, hauling, or even blasting with dynamite to remove the offending boulder so that it would not be a hindrance or a hazard the rest of the season.

After the field for the corn had been plowed, pulverized with the disc harrow two or more times, and made to look as smooth as black velvet with the spike-tooth harrow, it was ready to be planted.

27

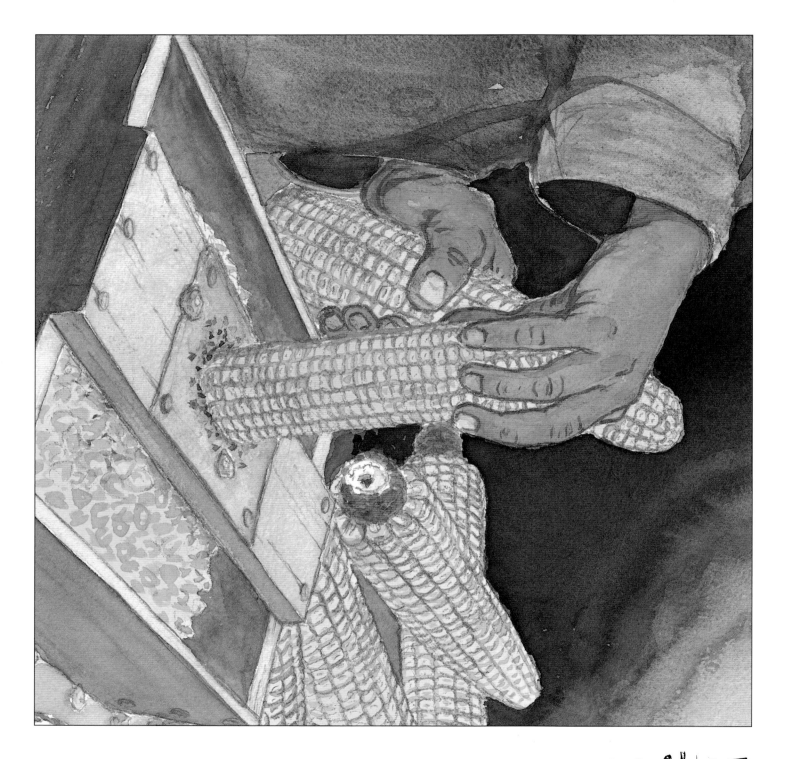

BEFORE HYBRID SEED CORN PLANTING INVOLVED A LOT OF ON-THE-FARM PREPARATION.

CHOICE EARS WERE SELECTED AT HARVEST TIME AND KEPT IN A DRY, SAFE PLACE UNTIL SPRING.

THE SEED WAS TESTED FOR GERMINATION. THEN THE PROVEN EARS HAD THE BUTT AND TIP KERNELS REMOVED — THIS LEFT THE REST OF THE EAR WITH KERNELS OF UNIFORM SIZE.

THESE EARS WERE THEN RUN THROUGH THE HAND SHELLER AND THE SHELLED CORN WAS SACKED AND READY FOR PLANTING.

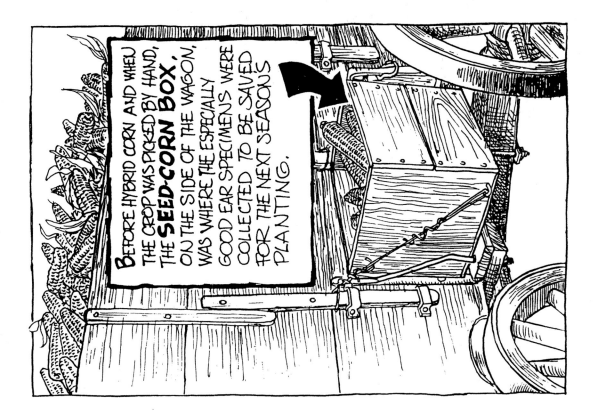

BEFORE HYBRID CORN AND WHEN THE CROP WAS PICKED BY HAND, THE **SEED-CORN BOX**, ON THE SIDE OF THE WAGON, WAS WHERE THE ESPECIALLY GOOD EAR SPECIMENS WERE COLLECTED TO BE SAVED FOR THE NEXT SEASON'S PLANTING.

SEED CORN SELECTION

Before the commercialization of hybrid seed corn, the farmer was his own geneticist. In the fall at corn-picking time, a box was fastened to the side of the corn wagon, and when a particularly good ear was husked, it was put in the box to be saved for next season's seed. These selected ears were stored away during the winter, where they would be safe from rodents and moisture. In the early spring, well before corn-planting time, two or three kernels were taken from each ear and put into a bed of sawdust that was kept moist until it was seen whether or not they sprouted. Some farmers used what was called a "rag doll" in this testing process. An old dishtowel was laid out with a layer of sawdust spread over it. Then the kernels to be tested were put into the moistened sawdust.

Dad had his own method. He bored a series of holes partway through a three-quarter-inch board, in a grid pattern corresponding to the wire drying rack the ears of corn were placed in. With about three kernels taken from each ear, imbedded in sawdust in the corresponding holes in the board, they were kept moist until they sprouted. The ears from which the kernels did not sprout were discarded, and the viable ears kept to be used as seed.

The ears chosen for seed were then "butted" and "tipped" in a wooden sheller Dad made for that purpose. With the odd shaped kernels of the butts and tips of the ears removed, the uniform kernels of the rest of the ear were saved for planting, since their uniformity would allow them to pass through the planter plates at the base of the seed boxes on the corn planter. The chosen ears were then shelled and the seed sacked and set in a safe place until planting time.

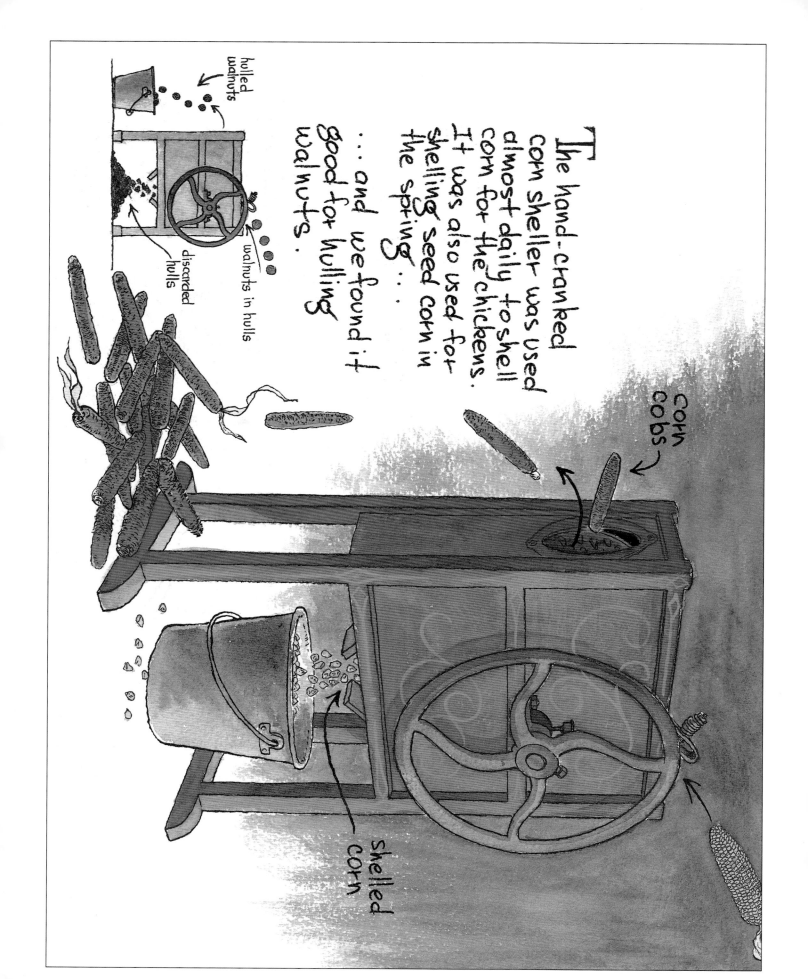

The hand-cranked corn sheller was used almost daily to shell corn for the chickens. It was also used for shelling seed corn in the spring...

... and we found it good for hulling walnuts.

hulled walnuts

discarded hulls

walnuts in hulls

corn cobs

shelled corn

THE CORN SHELLER

The corn sheller, along with the cream separator, was used on a daily basis to provide shelled corn for the chickens. Like the cream separator, it was powered by turning a crank. The crank was geared up to a flywheel, that, once you got it going, had enough momentum to carry the ear of corn through the shelling mechanism. Amid a loud clanking of its innards, the noisy machine shelled the ear of its kernels and spewed them into a pail underneath and tossed the naked cob onto a growing pile.

These cobs were a very useful by-product that was a part of our farm culture. First and foremost, they were used as a fuel for a quick, short-lived fire, and as a starter for a wood and coal fire. Soaked in kerosene, they could also be used to scour rusty plowshares, cultivator shovels, and hoes. Also soaked in kerosene and stuck on the end of a wire, a corncob made an excellent torch to thaw out a frozen pipe. The handy corncob also made

a stopper for a water or vinegar jug or kerosene can. We kids also used them in our play, as ammunition in our cob wars and more peacefully, as red Hereford cattle on our little farms.

However, the main purpose of the corn sheller was to produce shelled corn for our poultry and, in the spring, to provide shelled seed corn for the corn planter.

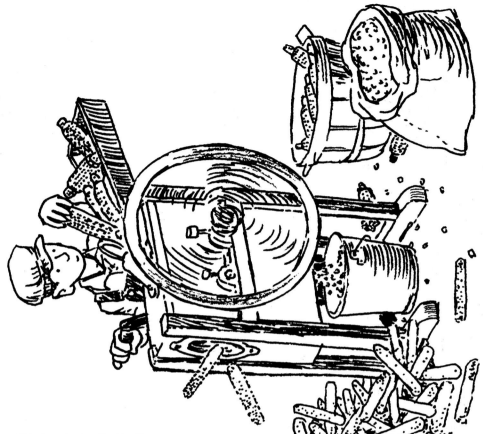

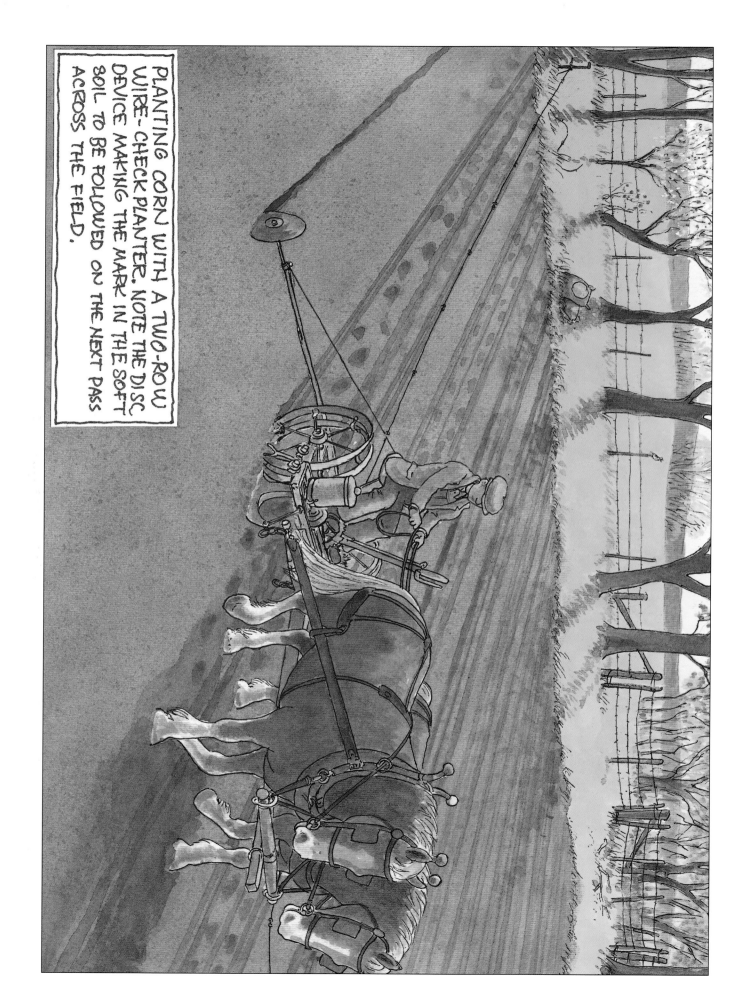

PLANTING CORN WITH A TWO-ROW WIRE-CHECK PLANTER. NOTE THE DISC DEVICE MAKING THE MARK IN THE SOFT SOIL TO BE FOLLOWED ON THE NEXT PASS ACROSS THE FIELD.

PLANTING CORN

It used to be said that when the new oak leaves were the size of a squirrel's ear, it was time to plant corn. Regardless of the folklore, corn was usually planted in about mid-May, when the soil was warm enough to encourage the kernels to sprout and not just lie there and mold. Since corn was our main crop, all other farm activity seemed to give way to preparing the ground and getting the seed planted. It was fortunate for us that Grandpa, after Dad had taken time from his busy schedule to plow and har-

row the garden plot, saw to the planting of our vegetables, while Mom was kept busy with setting hens and baby chicks.

After the corn ground had been given its final preparation, the corn planter was made ready. All the moving parts were oiled. The planting plates were put in the bottom of the two seed boxes and then checked to see that they were depositing the correct number of kernels with each thrust of the lever that would be activated by the button on the planter wire. The sacks of previously prepared seed corn were carried from storage and horses, planter, and seed were driven to the field.

First the coil of planter wire, with its buttons spaced about forty inches apart, was unrolled from one end of the field to the other and secured at each end by an iron stake pushed into the ground. Then the team, hitched to the planter, was aligned beside the wire, which was engaged into the "Y" yoke. This activated the planting mechanism. When the buttons on the wire tripped the lever as the planter moved across the field, the kernels were deposited into the ground. On the return trip it was the same procedure, with the team and planter following the furrow made by the marker on the previous pass.

It was the clickety-clack sound of the wire-check planters around the neighborhood that told us we were in corn-planting time.

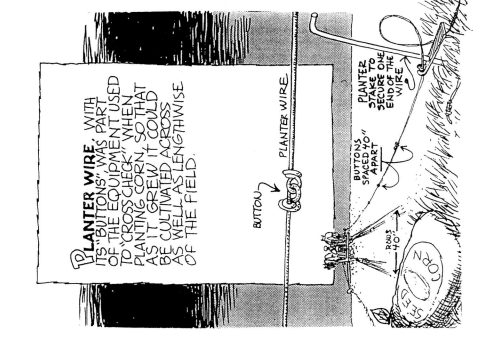

PLANTER WIRE, WITH ITS "BUTTONS" WAS PART OF THE EQUIPMENT USED TO "CROSS CHECK" WHEN PLANTING CORN SO THAT AS IT GREW IT COULD BE CULTIVATED ACROSS AS WELL AS LENGTHWISE OF THE FIELD.

BUTTON

PLANTER WIRE

PLANTER WIRE

BUTTONS SPACED 40" APART

PLANTER STAKE TO SECURE ONE END OF THE WIRE

ROWS 40"

SEED CORN

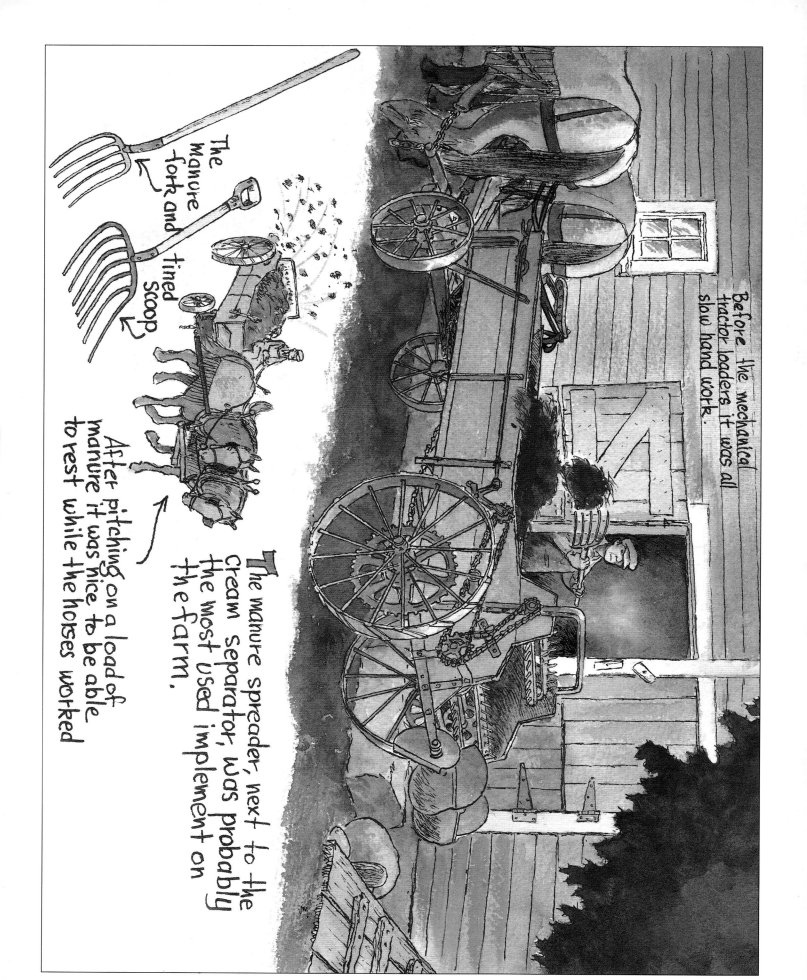

Before the mechanical tractor loaders it was all slow hand work.

The manure fork and tined scoop

After pitching on a load of manure it was nice to be able to rest while the horses worked

The manure spreader, next to the cream separator, was probably the most used implement on the farm.

THE MANURE SPREADER

It seemed like an awfully lot of farming was pitching manure. There were the horse stalls to clean daily during the summer and the cowbarn gutter daily during the winter. The hog house had to be cleaned periodically, as did the chicken house.

The cleaning chore I minded the least was cleaning the horse barn. Cleaned on a daily basis, the ammonia fumes were not overwhelming. Cleaning the hog pens was probably the worst. Hog manure was unbearably stinking, and the odor would permeate your clothes, even your skin, and cling to you for hours. Cleaning manure from under the roosts in the chicken house was a close second to working with pig manure, in being a detestable job. But all of this manure pitching was, of course, necessary, not only for keeping the pens and stalls clean, but in providing fertilizer for the fields. And this is where the manure spreader came in.

It was almost the most-used implement on the farm, winter and summer. In the spring, before the soil was tilled for the crops, the manure spreader was going back and forth from barn-

yard to field, spreading its contents over the awakening acres to enrich their fertility. From the calf pens, and the accumulated pile behind the cow barn and back of the hog house, manure was pitched on the spreader one forkful at a time to be hauled to the field.

The manure spreader was a fairly complicated machine. It was essentially a wagon equipped with a moving conveyor that moved the load backward into the beaters that spread the manure evenly in a strip behind. The chains, sprockets, gears, bearings, and levers involved in accomplishing this were subject to a lot of stress and wear, so it seemed Dad was fixing or replacing some part of the machine nearly as much as he was using it.

As some men dreamed of having a new car, Dad always wanted a new manure spreader. But that was not to be. Over the years he bought used spreaders and repaired and rebuilt them for as long as we were pitching and hauling manure.

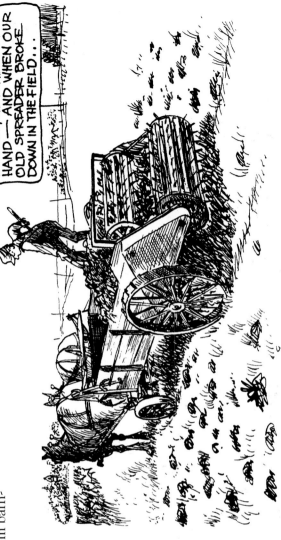

BACK BEFORE POWERED MANURE LOADERS, WE LOADED BY HAND — AND WHEN OUR OLD SPREADER BROKE DOWN IN THE FIELD . . .

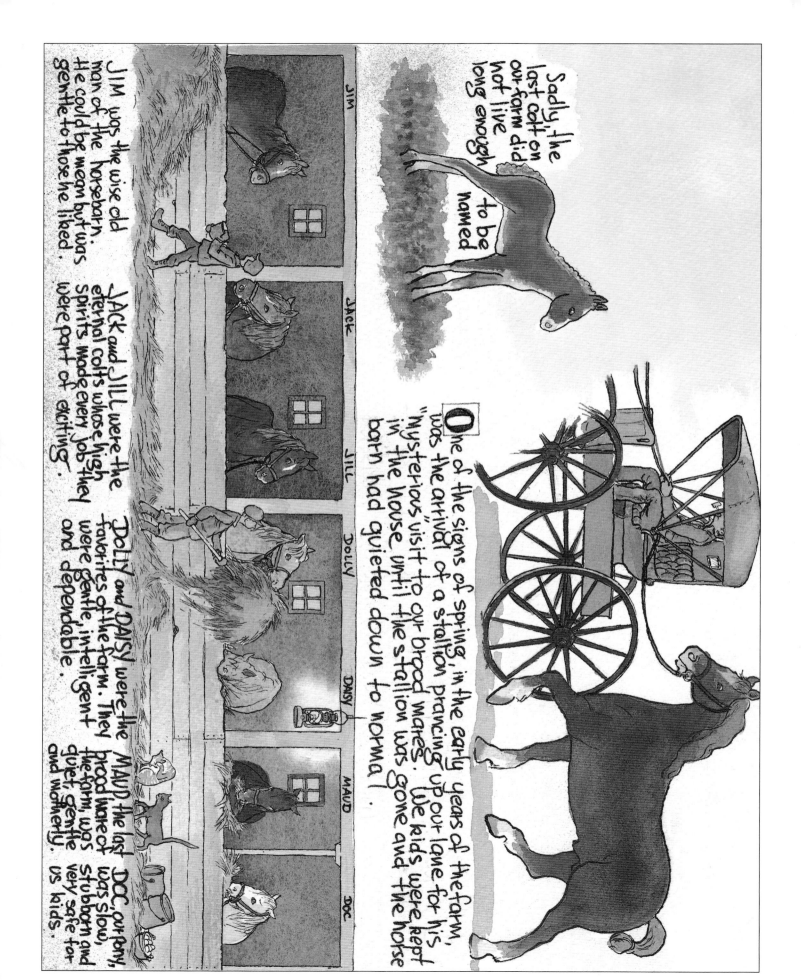

Sadly, the last colt on our farm did not live long enough to be named.

One of the signs of spring, in the early years of the farm, was the arrival of a stallion prancing up our lane for his "mysterious visit" to our brood mares. We kids were kept in the house until the stallion was gone and the horse barn had quieted down to normal.

JIM was the wise old man of the horse barn. He could be mean but was gentle to those he liked.

JACK and JILL were the eternal colts whose high spirits made every job they were part of exciting.

DOLLY and DAISY were the favorites of the farm. They were gentle, intelligent and dependable.

MAUD the last brood mare of the farm, was quiet, gentle very safe for us kids.

DOC, our pony, was slow, stubborn and motherly.

HORSEPOWER

During the early years of the farm our horsepower was provided by . . . horses. It wasn't until the middle 1920s that the first tractor came to the farm and provided a part of our horsepower. One of our horses, Turvey, was traded in on a Fordson tractor. It was a sad day when old Turvey was led off down the road, no longer a part of our farm.

Our horses were special creatures on our farm. They were not only very necessary as sources of power, they were friends—actually like family members—whom we became very fond of. When one of them would get sick, our concern went beyond the economic impact and became one of the heart. When one would die, which all of them eventually did over the years, we grieved for them as for one of the family. Dad was a gentle master, always putting their welfare ahead of the ever-present economic pressure. He was careful not to overwork them, especially in the heat of summer. If they showed any signs of illness he would call the veterinarian to examine them.

Each of these gentle beasts of burden had his or her own personality that alternately endeared them to us or drove us to distraction. Old Jim was irascible, just as likely to nip you as look at you, to everyone, that is, except Mom. With her, he was a gentleman and she felt perfectly safe around him. Jim seemed to despise our pony, Doc, and lunged at him with bared teeth every chance he got. But Doc had a champion in Dick, our old driving horse. When Jim would make his threatening move toward

Doc, Dick would dive between them, saving the pony from Jim's wrath. Our last old brood mare, Maude, was gentle and motherly. One spring she gave birth to a beautiful little bay who, sadly, didn't live to see the winter.

There were originally three brood mares on the farm: Queen, Jim's teammate; Topsy, who was Turvey's work partner; and Maude, the only one I knew. I don't know which of the three were mothers to Dolly and Daisy and Jack and Jill. Dolly and Daisy were blue roans and Jack and Jill were blacks with white feet and fetlocks. Jack had a white "J" on his forehead and Jill had a white splash on hers.

Jack and Jill seemed never to really grow up. They were high-spirited and flighty, requiring constant surveillance. Dolly and Daisy were just the opposite. They were the darlings of the horse barn, gentle, intelligent, and dependable. Old Doc, said to be part Arabian, was a good companion for us boys but not very exciting. When we tried to ride him or drive him hitched to our pony cart, he seemed to have his own agenda, which was to return to his stall.

Our horses were all of mixed breed, predominantly Morgan, except for Doc. But whatever their background, they were all a much-loved part of the farm. When the last horse died in the 1940s at a ripe old age, the stables were empty and lonely. On entering the horse barn we no longer heard the friendly nickering of our old helpmates . . . only the chirping of the sparrows.

EACH PEN HELD A SOW AND
HER LITTER OF EIGHT OR TEN
PIGLETS. AS EACH PIG WAS BORN
IT SOON FOUND ITS WAY TO ITS
FIRST MEAL AT THE MOTHER'S SIDE.

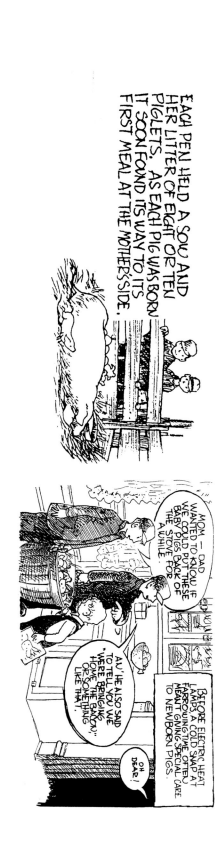

MOM — DAD
WANTED TO KNOW IF
WE COULD PUT THESE
BABY PIGS BACK OF
THE STOVE FOR
A WHILE.

AN' HE ALSO SAID
TO TELL YOU WE
"WERE BRINGING
HOME THE BACON"
OR SOMETHING
LIKE THAT.

OH
DEAR!

BEFORE ELECTRIC HEAT
LAMPS, A COLD SNAP AT
FARROWING TIME OFTEN
MEANT GIVING SPECIAL CARE
TO NEWBORN PIGS.

HOG HOUSE

The hog house was built in 1924. I know that because that was the first I had become aware of the years as dates. Dean and I were too young to help with the construction, but old enough to be under foot and asking questions as Dad and the two masons worked. It was built of glazed hollow building tile, manufactured in the brick and tile factory in nearby Sheffield. I still remember the hollow, bell-like sound of the tiles grating against one another as we kids clambered over them where they were stacked near the building site.

Wagonloads of fill dirt were hauled to build up and level the floor, and then one of our horses was led back and forth over it to pack the dirt before a layer of sand was spread over all. On top of the leveled sand, unglazed hollow floor tiles were laid. Then the whole floor was covered and smoothed with a layer of concrete. The smell of fresh-poured concrete at a building site, even today, reminds me of when the hog house was built.

In my early years, as I followed Dad around doing his hog chores, when one end of the old cattle shed was used to house the pigs, he used to share with me his dream of building a fine new building for them. So our new hog house was a realization of that dream. It made raising pigs, from farrowing time to market, much easier and more efficient. Farrowing pens were put along the sides, with an alleyway down the middle from the north to the south end. The partitions between these pens could

be removed as the piglets grew and were weaned from the sows, making space so they would have room for sleeping in deep straw and another area where they could feed from the hog troughs.

Farrowing time was, like all the new births every spring, an exciting time of newness. When the sows showed signs of farrowing, like "making nest" by carrying grass, straw, or even sticks in their mouths to a corner somewhere, they were put into one of the farrowing pens, made ready for them with fresh straw bedding and a pan of water. It was quite astounding for an eight-year-old to see squirming little beings, wrapped in something resembling cellophane, come slipping out of the mother pig's bottom. I watched bug-eyed as the squirming little creature struggled to its feet and started making its unsteady way around to the sow's side and began sucking on one of the teats on her belly. And then to see more of the same emerging, in rapid succession, gave me something to marvel at, think about, and talk about for quite some time.

If a cold snap occurred during farrowing time and the new-borns were chilled, Dad put them in straw at the bottom of a basket and covered it with a burlap sack and placed it behind the range. Before long these cold little pigs were scuffing around in the straw in the basket, emitting little grunts and squeaks. Having these cute little piglets in the house like pets, even briefly, was quite a treat for us kids.

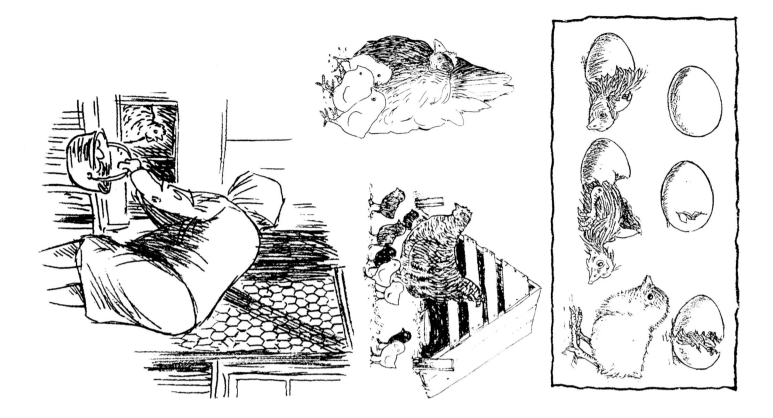

CHICKENS

Until we boys got old enough to do them, the chicken chores were Mom's. She fed them corn and oats, filled their water pans, and provided them with crushed oyster shell grit to make their eggshells firm.

Dad cleaned out the manure accumulation from under the roosts and hauled it to the field in the manure spreader as fertilizer. Then, with team and rack, he hauled in fresh straw to spread beneath the roosts.

Probably spring was my mother's favorite time tending the chickens. This was when some of the hens stopped laying eggs and "wanted to set." Their hormones became active and the "old clucks" would squawk and peck at our hands as we reached under them looking for eggs. An empty part of the corncrib became the hatchery. Here the "clucky" hens were put on nests with about a dozen carefully selected eggs. The grumpy old "clucks" sat on their clutch hour upon hour, day after day, leaving the nest only long enough to partake of the food and water provided for them and cluck and squawk at anyone that seemed to threaten their nest, in their maternity-ward prison.

It was amazing to see these "settin' hens" responding to eons of hormone programming, carefully taking their beaks and turning each egg. This was done every day so that the developing embryo would not adhere to the inside of the eggshell. After twenty-one days of incubation, the eggs began to hatch. This was an exciting time. First the egg cracked, with only the tip of the tiny beak showing. Then the wet, scrawny chick struggled and pushed and finally worked itself free from the confining eggshell. The chick proclaimed its birth with loud cheeps and in no time at all was a fluffy little ball of down, running around to the clucking call of its excited new mother.

Soon thereafter, mother hen and baby chicks were moved to individual coops that would be their home until the chicks became gangly young fries, having lost their soft down and sprouting pinfeathers to cover their nakedness, and their voice had changed from "peeps" to adolescent squawks.

In order to make the hatching process more efficient, Dad, with Mom's help, built a "setter." After buying some twelve-inch-wide rough-cut boards and some woven chicken wire, they made a rectangular box, sixteen by eight feet. Within this were twelve covered nests and wire-covered runs with feed and watering area. Each hen had a private space, secure from rain and predators.

Eventually we no longer hatched our own chicks but bought day-old chicks from a commercial hatchery. Dad and Grandpa built a brooder house, which had a vented oil-fueled heater with a sheet-metal brooder. Under this the chicks huddled to keep warm on the cool spring nights. It was exciting to bring home the cardboard boxes with their soft cheeping contents and take them out, one by one, dipping their little beaks into watering pans, so they would know how to drink. But we did miss the old days, when the clucking mother hens herded her little brood around the farmyard, instructing them how to scratch and pick up tidbits.

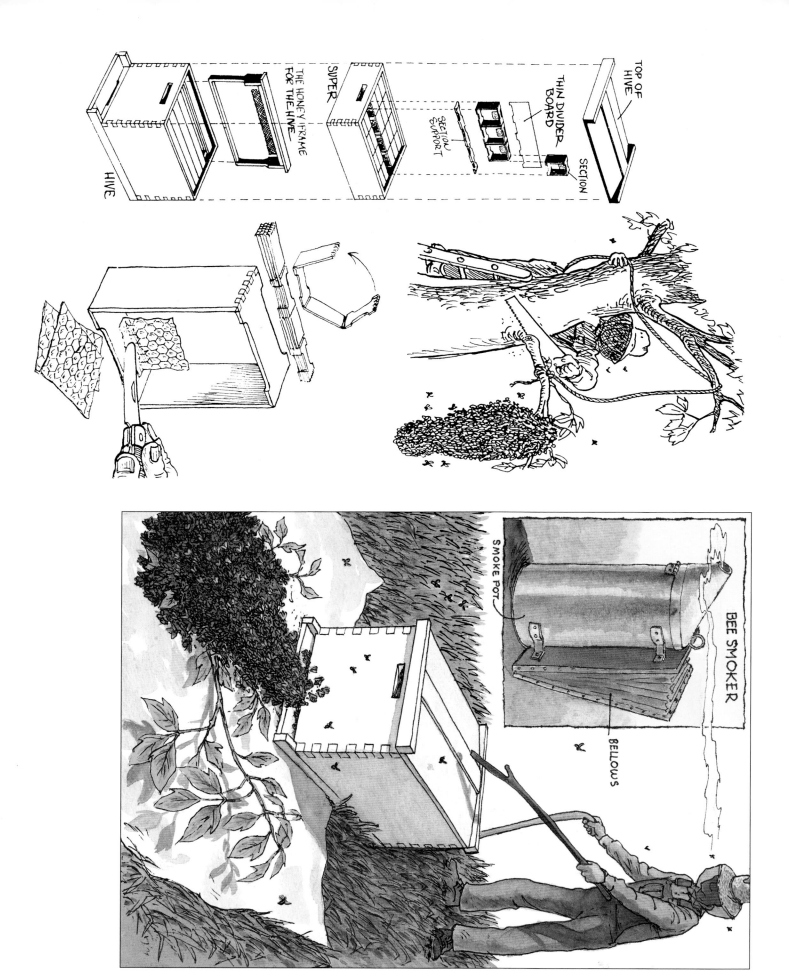

TOP OF HIVE

SUPER

THE HONEY FRAME FOR THE HIVE

HIVE

SECTION SUPPORT

THIN DIVIDER BOARD

SECTION

BEE SMOKER

SMOKE POT

BELLOWS

BEES

"The bees are swarming! The bees are swarming!" This cry of alarm set the farm into an emergency mode much the same as a cry of fire. We scrambled to get the previously prepared new or cleaned old hive, a white sheet, and the bee smoker collected, ready to see where the noisy swarm was going to land. If the loud buzzing cloud, following its queen, settled on a high branch on one of the tall trees around the yard, we boys took off at a run to alert Dad so that he could come in from the field to climb up and capture the swarm before they took off across the fields and were lost to us.

Grandpa was the beekeeper and cared for them in every way. If the swarm had landed on one of the lower limbs or bushes, he would set about collecting the swarm by himself. After placing a newly prepared hive on a white sheet on the ground near where the swarm was clustered, he would carefully cut the branch loose and lay it and the swarm on the sheet in front of the hive. Then he would tap the top of the hive (I don't know why this worked, but it seemed to) until the buzzing, agitated mass of bees, led by their queen, streamed into the slot at the base of the hive to claim their new home.

Eventually, however, due to Grandpa's rheumatism and stiff joints, he could not climb the tree, cut off the branch that the swarm was attached to, and lower it onto the sheet. Therefore, that exciting task fell to Dad, who, despite having his fieldwork interrupted, seemed to enjoy the challenging adventure.

The reason there was such frantic activity at the first sign of their swarming was that if we did not get the swarm captured before their scouts returned from their search for a new location, the swarm would follow them. I used to wonder about the fate of the scouts, when they returned with their message to discover that the swarm had already found a place.

We boys found Grandpa's beekeeping added an exciting element to the farm. We also enjoyed the anticipation of helping Grandpa unpack the package when his order of bee supplies came from Montgomery Ward. The pre-cut parts of the hive, of white pine lumber, smelled of new wood, as did the pre-cut bass-wood sections. These we were allowed to help fold and lock into place. But Grandpa insisted on attaching the little squares of pressed honeycomb, cut from a sheet of the material, for the bees to use as a foundation in building their comb of honey.

In the autumn, when the hives and the supers (the boxes on top of the hives containing the pound sections of honey) were filled, it was time for harvest. Using the bee smoker (a smoke pot with a bellows attached) he subdued the angry bees with a few puffs of smoke and removed the honey-loaded super. The hive box on the bottom was left undisturbed so that the swarm would have honey to see them through the winter. The squares of comb honey from the supers was packaged into attractive boxes with cellophane windows and sold to grocery stores. This was the "rent" the bee colonies paid Grandpa for providing them a home.

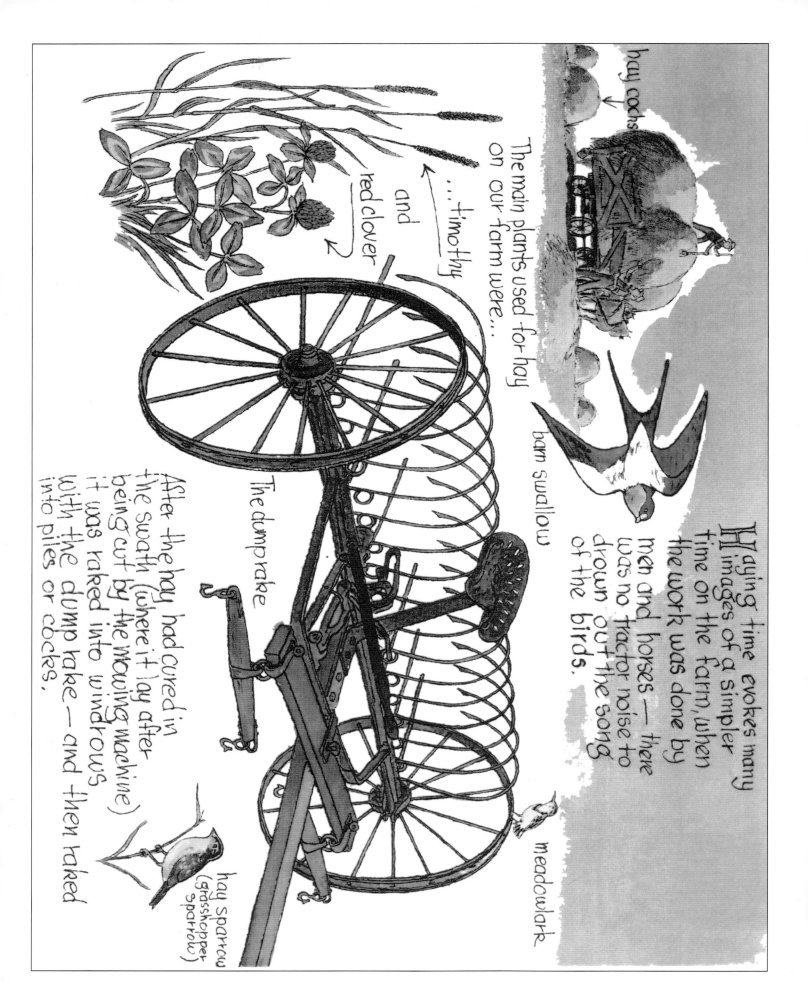

hay cocks

The main plants used for hay on our farm were...

...timothy

and red clover

barn swallow

The dump rake

meadowlark

Haying time evokes many images of a simpler time on the farm, when the work was done by men and horses — there was no tractor noise to drown out the song of the birds.

After the hay had cured in the swath (where it lay after being cut by the mowing machine) it was raked into windrows with the dump rake — and then raked into piles or cocks.

hay sparrow (grasshopper sparrow)

SUMMER

MAKING HAY

Making hay was my favorite harvest. It was, to be sure, hard, hot and dusty work. But to be able to gather the new hay safely into the mow or stack without rain on it was a satisfying accomplishment.

It was our first harvest of the season, usually in June. The summer was at its newest and the fields were alive with bird songs. Gentle breezes wafted the sweet fragrances of earth and curing hay across the sun-warmed fields, a balm to our hot, aching bodies.

In the early years on our farm, we harvested two kinds of hay: "Tame" hay, made up of red clover (whose bloom emits one of the richest perfumes of any flower) and timothy, and "wild" hay—the native grasses and herbaceous plants that grew in a strip of virgin prairie on the "forty," north of the road. This wild hay had its own unique mixture of fragrances. Apparently it tasted as

good as it smelled, since the horses were fond of it.

Our haying equipment, in those early years, was all horse drawn. It consisted of a mower and a dump rake, and of course the hayrack or hay wagon. First the mower cut the standing hay into swaths, where it was allowed to cure in the sun and drying breezes for a day or two. After the hay had cured, it was raked up into long windrows with the dump rake. Then, using the same rake, the windrows were gathered into individual piles or cocks. Using pitchforks, the hay from the cocks was loaded by hand onto the hayrack and hauled to the barn for storage.

Often the wild hay was stored in stacks in the field. One of my early memories was of watching Dad and his helpers, using a wooden, horse-powered, mechanical stacker, building such a stack. Besides the stacker, two horse-drawn "buck" rakes were used to move the haycocks up to the wooden machine that lifted them onto the stack, where one or two men with pitchforks formed the hay into a weatherproof stack.

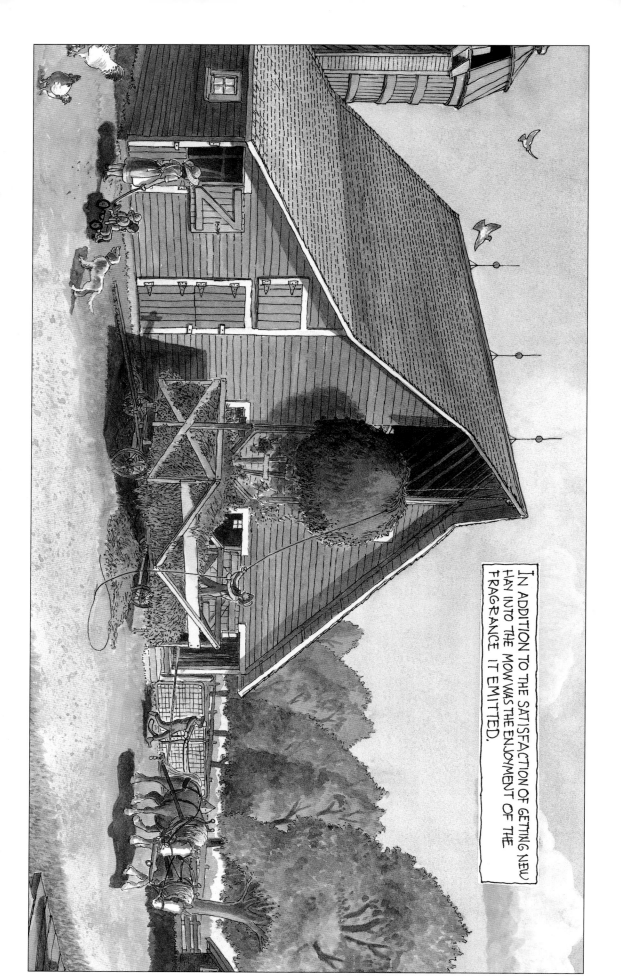

IN ADDITION TO THE SATISFACTION OF GETTING NEW HAY INTO THE MOW, WAS THE ENJOYMENT OF THE FRAGRANCE IT EMITTED.

PUTTING HAY IN THE BARN

The clover and timothy hay was usually hauled to the barn where it was lifted into the mow, or hayloft, by means of a harpoon hayfork, and pulleys and ropes. This, like the work in the hayfield, was done by the use of horsepower. The crew here consisted of one man on the load who set the fork into the hay and then watched as the horses, driven by a man or boy, pulled the rope that, through a series of pulleys, wound its way to the hay fork and lifted a large forkful up into the mow. Here it was dumped by the man on the load, by jerking on the trip rope. This process was repeated several times until the wagonload of hay was transferred into the barn.

Probably one of the worst haymaking jobs was that of the one or two men in the hot, stuffy haymow, who, with pitchforks, leveled the growing pile of hay, pushing it under the eaves. The material benefits of all this hard work in the dust and heat came at noontime when we were rewarded by a delicious dinner and a short rest.

Our well, with its clear, cold water, was never more appreciated than when laboring under the summer sun. The most refreshing drink I know was from the rusty tin cup that hung by the pump, or a swig of cool water from the burlap-wrapped stone jug, while out in the hot, dry stubble of a hay or oat field.

Going into the barn, or even walking past it, after the mow had been filled with new hay, was an olfactory delight to me, as I inhaled the fragrance it produced when going through its sweat.

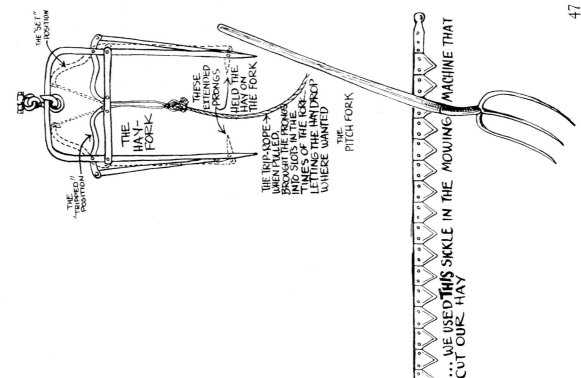

THE "SET" POSITION

THE "TRIPPED" POSITION

THE HAY-FORK

THESE EXTENDED PRONGS HELD THE HAY ON THE FORK

THE TRIP-ROPE WHEN PULLED, BROUGHT THE PRONGS INTO SLOTS IN THE TINES OF THE FORK LETTING THE HAY DROP WHERE WANTED

THE PITCH FORK

... WE USED **THIS** SICKLE IN THE MOWING MACHINE THAT CUT OUR HAY

THE SICKLE, AN ANCIENT TOOL FOR CUTTING HAY AND GRAIN ...

THE EVAPORATION OF THE SOAKED BURLAP AROUND THE WATER JUG KEPT THE CONTENTS COOL FOR A REFRESHING SWIG IN THE HOT HAYFIELD

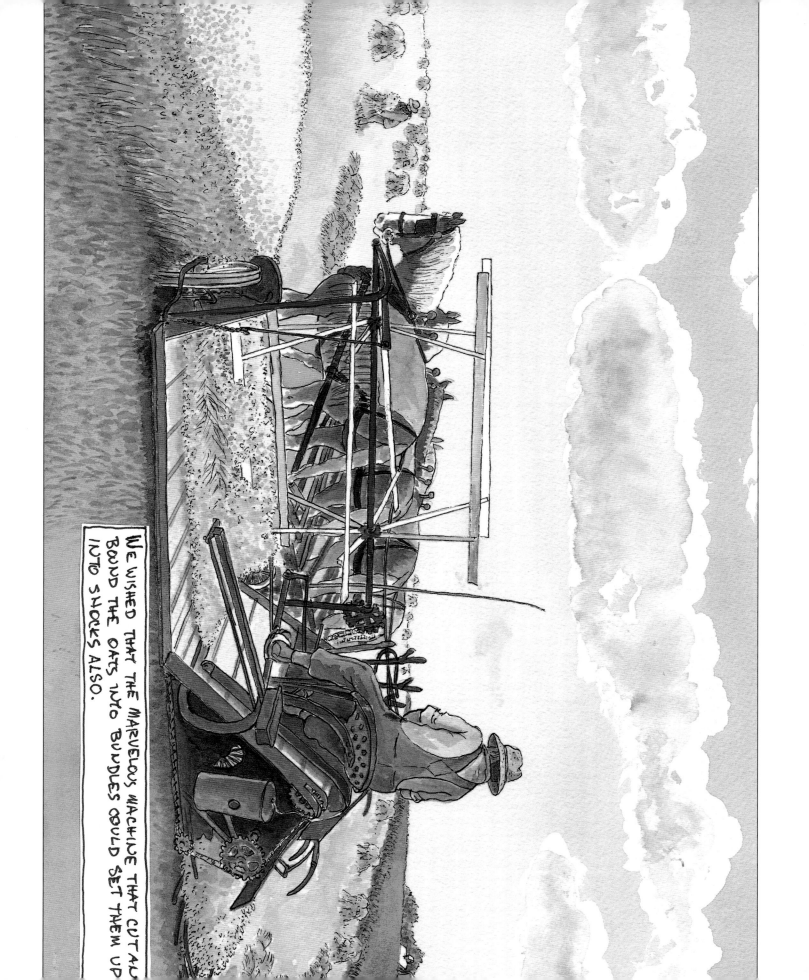

WE WISHED THAT THE MARVELOUS MACHINE THAT CUT AND BOUND THE OATS INTO BUNDLES COULD SET THEM UP INTO SHOCKS ALSO.

SHOCKING OATS

Grandpa would tell us about how he used to harvest oats when he was young. He used a scythe and cradle. I was acquainted with a type of scythe, but the one Grandpa described had a rocker or cradle attached that caught the cut-off stalks of grain. Then, with each swing of the scythe, the accumulated stalks were laid in a pile on the stubble. The one binding the sheaves would gather the pile up and, taking a fistful of the stalks and using them like twine, bind up the bundle.

This all seemed very primitive and like a lot of work to us. We thought merely setting the tied bundles up into shocks was hard, hot work. But having to cut and bind the grain by hand too was inconceivable. The mechanical, horse-drawn binder did both—cut the standing grain and tie it into bundles.

There was a lot of work each year in getting the binder ready for the oat harvest. I remember Dad sitting cross-legged in the cool grass in the shade of an ash tree, with a binder canvas across his lap. With a large needle and strong cord he stitched, closing rips and patching holes in the canvas that would soon be installed in the oat binder. This slatted canvas, made of heavy duck material, moved over rollers carrying the cut stalks of grain up into the binder, where it would be automatically tied into bundles and dropped into windrows. From these windrows, the shockers set the bound sheaves up into shocks. The bundles weren't heavy, but even young backs felt the strain of stooping up and down for hours on end. And being that this exhausting work was done during the heat of July, it was not a pleasant job to anticipate.

Two or three shockers following the binder could keep up fairly well. However, to go into a field where the binder had already been and gone and to see all those windrows of bundles lying in the hot sun waiting to be set up into shocks was not a pleasant sight. We knew from experience, even before we began, the feel of the crackling dry bundles pressed against our sides as we jostled them into position and set them down into the hot, dry stubble. The dry chaff and dust would work its way into our clothes and stick to our sweaty, itchy skin. We thought longingly of a plunge into the cool waters of the creek. The only immediate relief was a swig of water from the soaked-burlap-wrapped earthen jug, with its corncob stopper, that we had filled at the well before coming to the field.

Sometimes as a reward, after a day in the hot oat field, and after the evening milking was done, Dad would take us to our favorite sandpit pool. Since this place was secluded, with Dad joining us, we all went skinny-dipping in the cool water. What a blessed relief to our sweaty, sunburned, itchy bodies! After drying off and dressed in clean clothes, we felt renewed—ready for another day in the oat field.

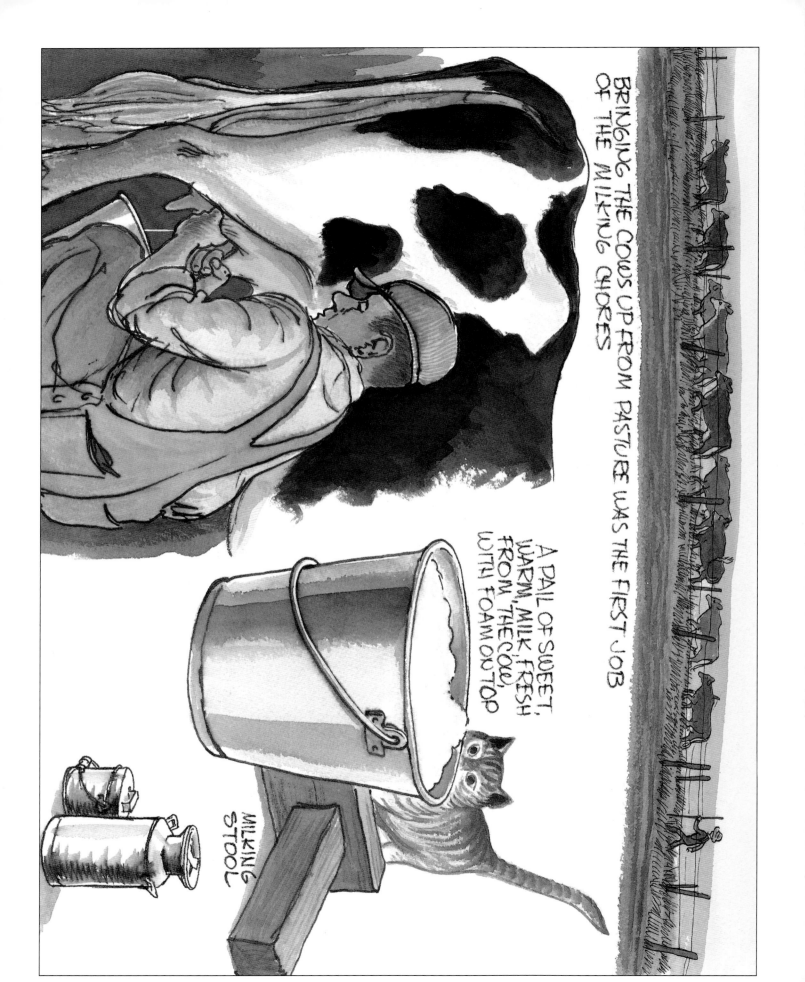

BRINGING THE COWS UP FROM PASTURE WAS THE FIRST JOB OF THE MILKING CHORES

A PAIL OF SWEET, WARM MILK, FRESH FROM THE COW, WITH FOAM ON TOP

MILKING STOOL

MILKING TIME

Dairying was only a small part of our diversified farming program, even though, when we sat down to milk the eight or ten cows by hand, it didn't seem small. Summer was when our milking chores were at their height. The cows, having freshened in the spring and turned into verdant pastures sometime in May, were at the peak of their production.

The milking chores in the summer began with getting the cows up from pasture. This could be the best part of the milking process, as far as we kids were concerned. If the milk cows were not waiting at the pasture gate but were with the rest of the cattle in the far reaches of our lowland pasture, it meant selecting our walking stick from its place in the fence corner and setting off across the bogs to wherever they were. This could be a small adventure when we would encounter some of the wild creatures that were denizens of this uncultivated area of the farm. There were skunks (to be avoided), red-tailed hawks, blue herons, and many other wading birds along the creek. Occasionally we would come upon a snapping turtle and, very rarely, spy a red fox.

The down side of milking in the summer were the pesky flies and the mud that the cows often stood in to escape their bite. This meant that before sitting down to milk we had to wash off the cows' mud-caked udders. Also, before milking, we had to spray the sides, backs, bellies and legs of the cows with a concoction that was supposed to keep the flies off and give the poor critters a bit of peace while we milked them. This was not entirely for the cow's benefit alone, but for us as well, in that we wouldn't have to deal with flailing tails and kicking hooves.

When the corn had begun to reach the roasting ear stage, the cattle began to tire of their grass fare and would all too often break down a fence to feed on the taste of new corn. These escapades caused a lot of trouble getting the errant bovines out of the cornfield and back into the pasture and then repairing the fence, and made us late doing the milking. Worse yet, as the milk cows struggled through the broken fence, a barb on the wire would sometimes slice a teat. This would take special care for several days and cause pain for the cow when being milked, making the milking session an ordeal for the cow as well as the milker.

With sore teats, biting flies, muddy udders, and suffocating heat in the cow barn, milking time in the summer was not a pleasant experience, yet this was when the milk production was at its peak.

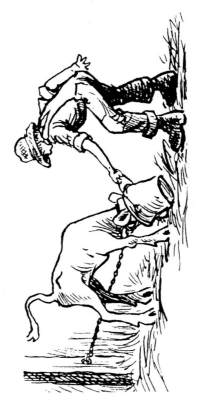

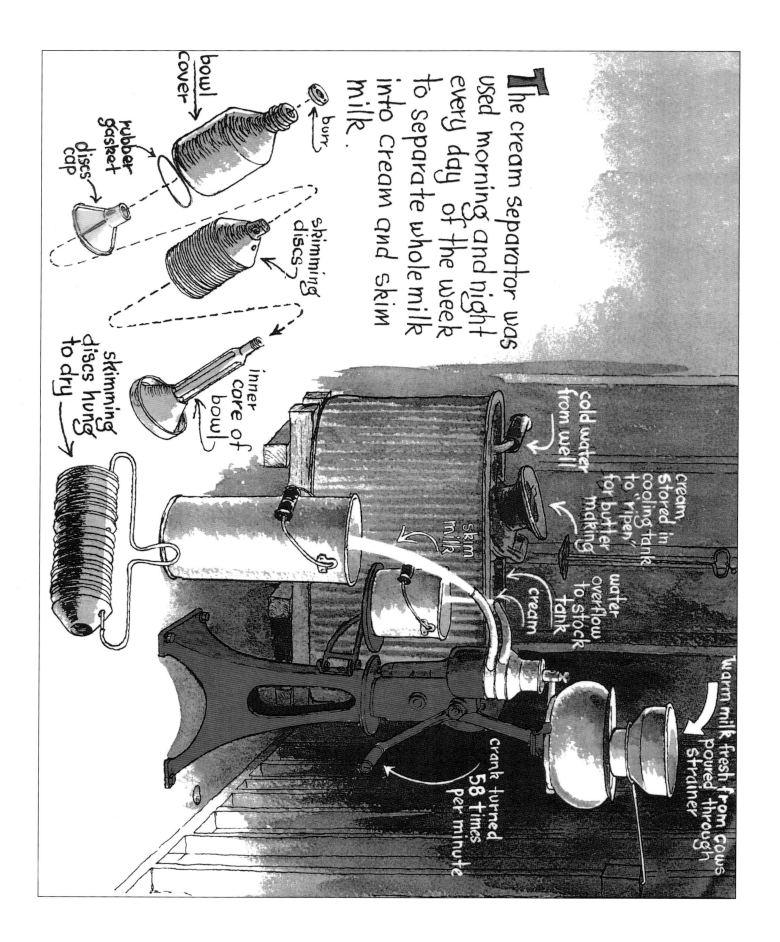

The cream separator was used morning and night every day of the week to separate whole milk into cream and skim milk.

bowl cover

burr

rubber gasket

discs cap

skimming discs

inner core of bowl

skimming discs hung to dry

cold water from well

cream stored in cooling tank to 'ripen' for butter making

water overflow to stock tank

skim milk

cream

crank turned 58 times per minute

Warm milk fresh from cows poured through strainer

THE CREAM SEPARATOR

During those years when we were milking by hand, we did not sell whole milk but sold the cream to the creamery to be made into butter. After we had finished milking and while the milk was still warm from the cow, it was strained and run through the cream separator. This hand-cranked machine, by means of a high speed-spinning bowl made up of a series of metal discs, mechanically separated the cream from the milk. During the separating process, with the stream of fresh cream pouring out of the cream spout, some of it was caught in a pitcher for the table. Breakfast cereals or fresh strawberries never tasted better than when covered with fresh, rich cream. The enjoyment of this rich fare no doubt contributed to my bypass surgery some seventy years later.

While the skim milk, a byproduct of the separating process, was still warm with the animal heat, some of it was fed in buckets to the young calves. The rest was poured into the swill barrel, where it was mixed with ground oats, linseed meal, and water, and fed to the pigs.

Washing the parts of the separator through which the milk and cream passed was an irksome, tedious task. There were

about fifty complicated tinned parts with hard-to-get-to places. The most tiresome part of the job was the forty-some metal cone-shaped discs through which the milk passed in the spinning bowl, where the process that separated the cream from the milk took place. Each disc had to be washed, rinsed, and then strung one at a time in sequential order on the drying rack.

The container of still-warm cream was set into the cooling tank, then later added to the collection of the past few days in the cream can. The cream cans were kept in the cooling tank and, twice a week, hauled to the creamery in the village of Latimer, to be made into butter.

We boys enjoyed going with Dad to take the cream to the creamery. We watched with interest as the buttermaker, clad in white, first stirred the cream and then took out a small sample to test for butterfat content. (We were paid on the basis of the percentage of butterfat the cream contained). Then he weighed the full can and dumped the contents through a strainer into a large vat that would later be transferred into the large churn. The churn was one of two that were driven by belts from an overhead shaft of pulleys powered by a large electric motor.

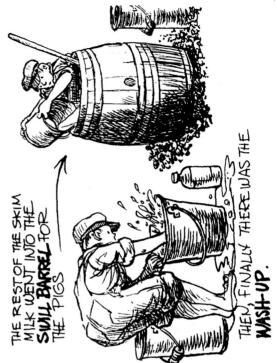

THE REST OF THE SKIM MILK WENT INTO THE **SWILL BARREL** FOR THE PIGS

THEN, FINALLY THERE WAS THE **WASH-UP**.

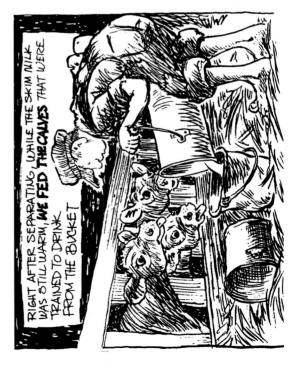

RIGHT AFTER SEPARATING, WHILE THE SKIM MILK WAS STILL WARM, **WE FED THE CALVES** THAT WERE TRAINED TO DRINK FROM THE BUCKET

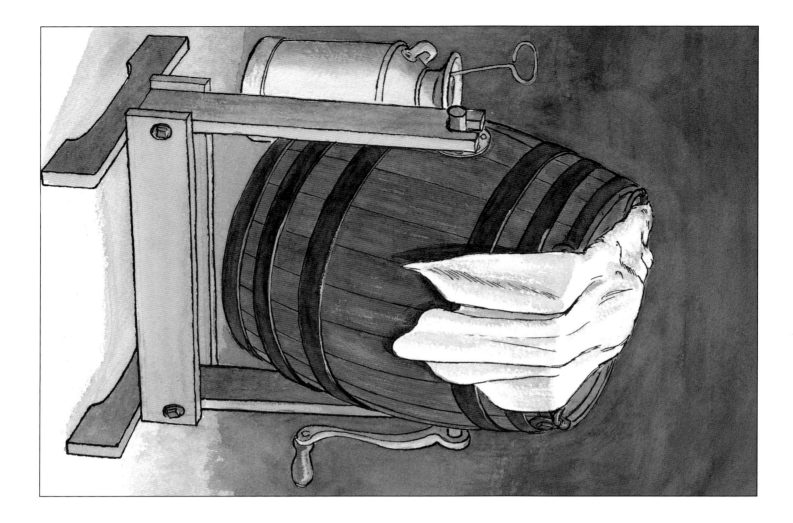

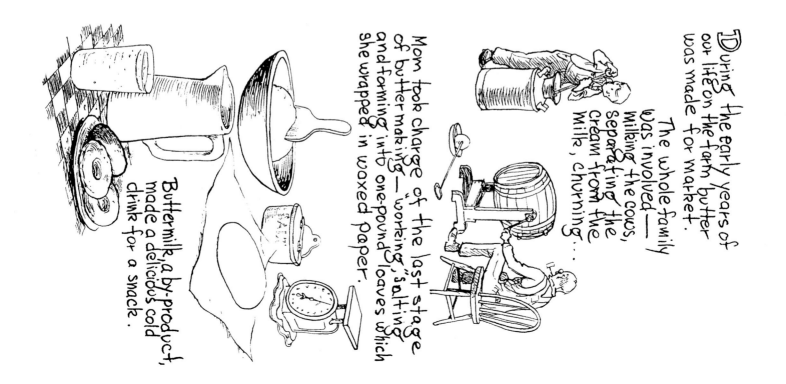

During the early years of our life on the farm butter was made for market.

The whole family was involved—milking the cows, separating the cream from the milk, churning...

Mom took charge of the last stage of buttermaking—"working," salting and forming into one-pound loaves which she wrapped in waxed paper.

Buttermilk, a by-product, made a delicious cold drink for a snack.

MAKING BUTTER

In the early years of the farm, the cream was not taken to the commercial creamery to be made into butter. Instead it was made into butter in our kitchen. The "ripened" cream was poured into a wooden barrel churn, where it was agitated by turning the churn with a crank. It seemed, sometimes, to take ages for the butter to "come" (coagulate into globules of butterfat).

When the butter was formed, Mom would pour off the buttermilk and then "work" or knead the mass of butter in a big wooden butter bowl, extracting all the remaining buttermilk, and add salt. After the butter had been thoroughly worked, Mom formed it into one-pound patties and wrapped them in waxed paper. Thus prepared, the butter was taken to town and, together with eggs, traded for needed groceries.

When we were hauling our cream to the commercial creamery in Latimer, we felt fortunate if we happened to arrive when the buttermaker was emptying one of the big churns of its golden product. (The butter color, incidentally, was added to the

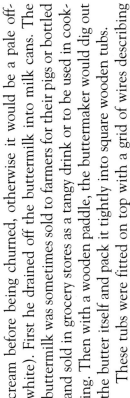

cream before being churned, otherwise it would be a pale off-white). First he drained off the buttermilk into milk cans. The buttermilk was sometimes sold to farmers for their pigs or bottled and sold in grocery stores as a tangy drink or to be used in cooking. Then with a wooden paddle, the buttermaker would dig out the butter itself and pack it tightly into square wooden tubs.

These tubs were fitted on top with a grid of wires describing the shape of a dozen pounds of butter. By means of a jack lever, the whole mass within the tub was raised to a prescribed height and then, by drawing a wire from one end to the other, the buttermaker would cut off twelve blocks of butter, each weighing one pound.

It was fascinating to watch him as he deftly wrapped each one-pound block in waxed paper imprinted with the creamery's logo. These packages were stored in a cooler until delivered to grocery stores. We also took one or two of these packages of butter as part payment for the cream we had brought that day.

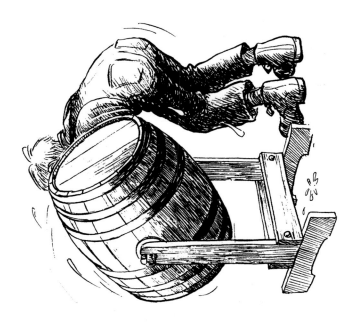

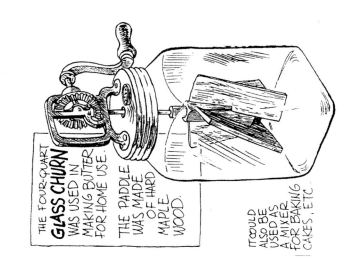

THE FOUR-QUART **GLASS CHURN** WAS USED IN MAKING BUTTER FOR HOME USE.

THE PADDLE WAS MADE OF HARD MAPLE WOOD.

IT COULD ALSO BE USED AS A MIXER FOR BAKING CAKES, ETC.

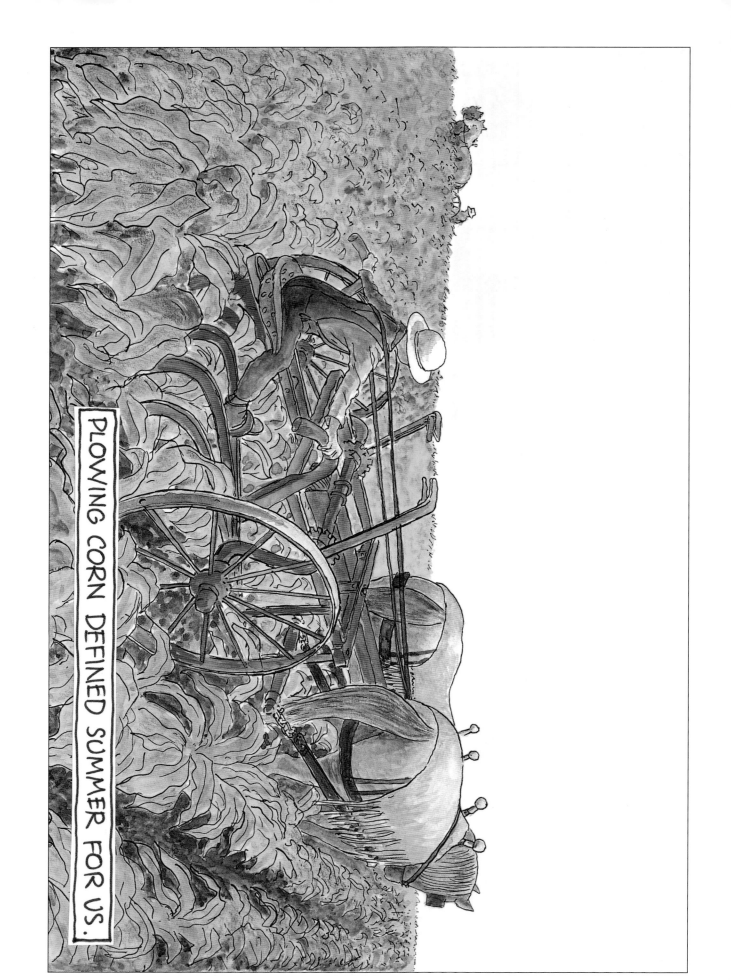

PLOWING CORN DEFINED SUMMER FOR US.

PLOWING CORN

The corn-plowing season, when I was a kid old enough to take part, was an ongoing field task that seemed to define summer. Actually it lasted from when the young plants first emerged in about mid-May until shortly before they started to shoot tassels in about mid-July. There were breaks in the pervasive summer field work, like taking off for the Fourth of July or when we took time out to make hay.

In the midst of the corn-plowing season, a fine summer day would begin after the chores were done and the cows taken to pasture, and after eating a hearty breakfast, by first currying, brushing, and harnessing the horses and hitching them to the single-row cultivator.

Perched on the stamped-iron seat, riding to the field, I felt like I was riding one of the racing sulkies at the county fair. A light breeze carried the scent of the green fields and the songs of the meadowlarks and plaintive cry of the killdeer. As I turned the horses into the rows of corn, picking up where we had left off the night before, I lifted the beams off their hooks and set the shovels into the soft dirt. The reins from the horses were tied in a loop so that I could run them over one shoulder, across my back, and under the other arm. This arrangement left my hands free to hang onto the curved wooden handles on each beam and guide them down the rows. The horses pretty well followed the rows, so I only had to take the reins at the end when turning into the next row.

Plowing corn was a job that did not require much thought, except steering the shovels clear of the corn plants and, at the same time, trying to take out as many weeds and as much grass as possible. This all became quite automatic, without conscious thought, leaving plenty of time to daydream as we worked our way across the field. And what air castles I did build, those summers while plowing corn!

Dean, on his single row and me on mine, even made up a work song of sorts. We would belt it out with gusto, drowning out the song of the birds, the sound of the corn leaves rustling in the breeze, and that of the steel wheels grating on an occasional pebble in the soft loam. I'm sure the song will not be found in any anthology of work songs. It went something like this:

Get up Daise, Doll—we're waiting
To get started cultivating,
The corn's a-growing,
The weeds are growing,
It's getting late in the season
And that is just the reason,
We've got to hurry and scurry
To get done plowing corn.

We inserted the names, Jack, Jill, Jim, or Maude, when they were the horses hitched to the plow.

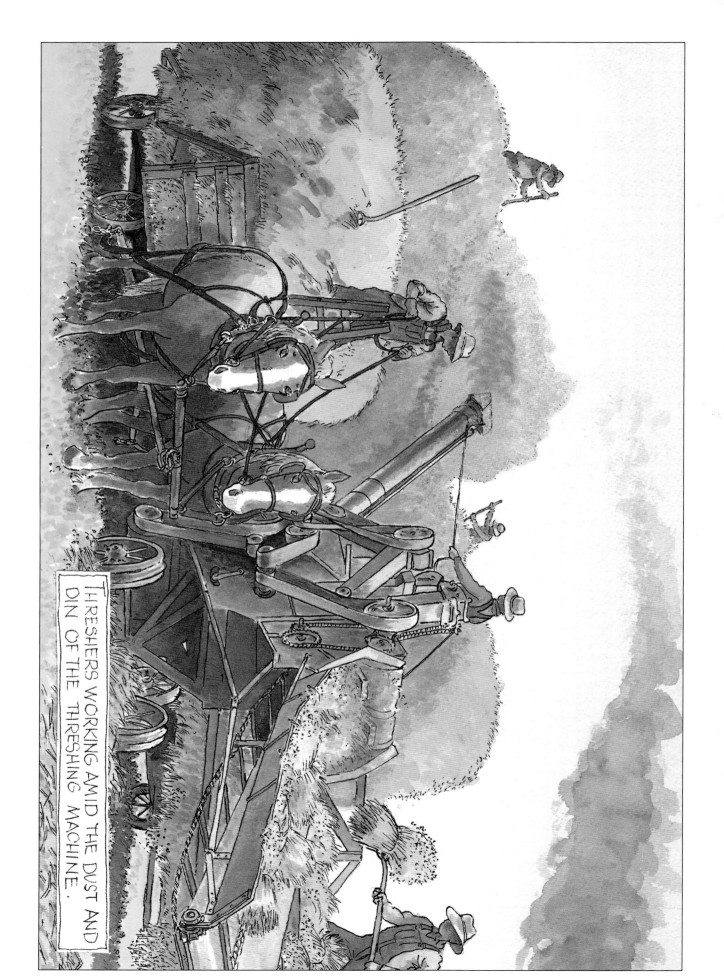

THRESHERS WORKING AMID THE DUST AND DIN OF THE THRESHING MACHINE.

THRESHING

Threshing time, when we were kids, rated right up there with the county fair or a circus. It was exciting. Often the steam engine, moving like a slow-moving train, pulling the threshing machine and the water wagon, came chuffing up our lane, toward the end of a day of threshing at a neighboring farm. The rig was pulled into our yard and parked for the night, before the engineer banked the coals in the firebox and went home.

Early the next morning he would be back to stoke up the fire and pump water from the water wagon into the boiler so that steam pressure could be built up and ready to go by the time the dew had dried on the oat shocks in the field. About that time the threshers, driving their bundle racks, began to assemble and proceed to the oat fields to load up the bundles. In the meantime, checking the wind direction, Dad and the engineer and separator operator had set up the threshing rig, ready to begin the day's work.

Before long, the roar and clatter of the threshing machine all but drowned out the quiet chuffing of the steam engine. The steamer spewed out steam and smoke from its coal fire, and the separator spewed out straw, chaff, and dust from its blower pipe onto the straw pile. The grain, being threshed and separated from the oat straw, was automatically measured into a wagon alongside the separator, which would then be hauled to the oat bin for storage.

Probably the dirtiest, most exhausting job on the threshing crew was that of stacker, who had to take all of that straw, chaff, and dirt being blasted at him and try to make it into a decent-looking straw stack that would stand at least long enough to get his pay. The stacker was the only one of the crew getting paid.

About noon, a long blast on the steam whistle brought everything to a stop. All hands made their way to the house yard, beating the dust and chaff from their clothes. Soap and water and towels had been set upon a temporary bench under the Duchess apple tree, where even a mirror had been hung.

Their ablutions completed, the threshers filed through the kitchen, shyly acknowledging Mom and the women helping to put the meal on the table, and on into the dining room. Seated around the extended table, the hungry crew dug into the "threshers dinner" that had been prepared for them. Some friendly banter was exchanged, but mostly everyone was intent on eating, before another blast on the steam whistle called them back to work. What payday was to the army, dinnertime was to the threshers. And this was their pay. Since the threshers were neighbors helping one another, no money exchanged hands, except to pay for the use of the threshing rig.

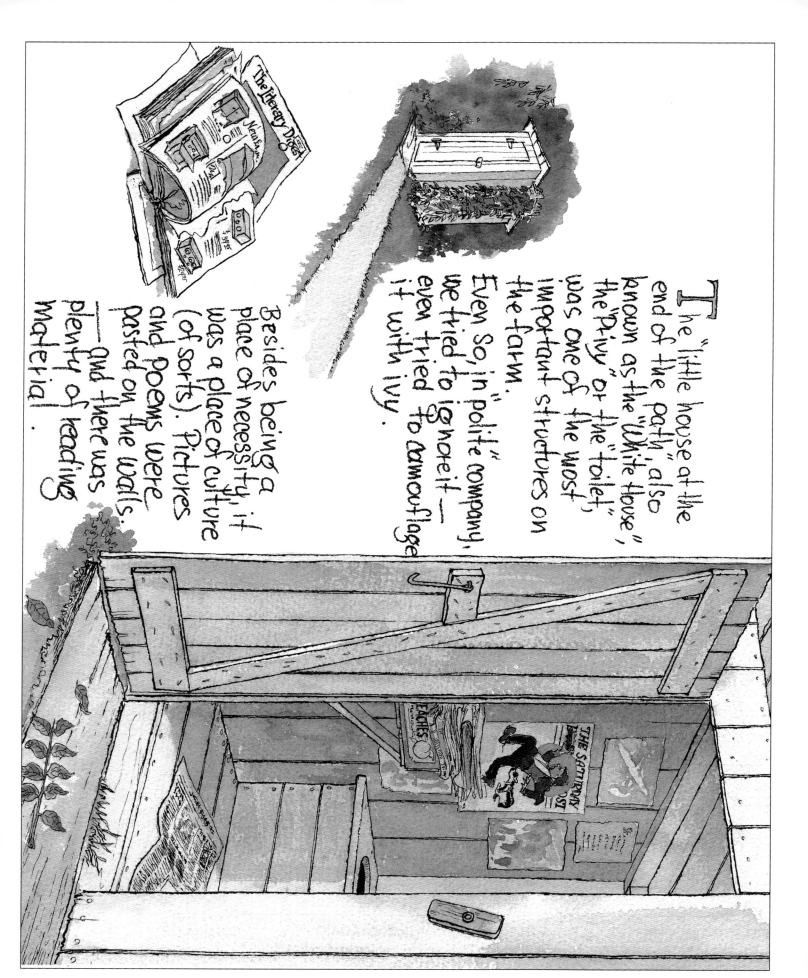

The "little house" at the end of the path, also known as the "White House", the Privy or the "toilet", was one of the most important structures on the farm.

Even so, in polite company, we tried to ignore it — even tried to camouflage it with ivy.

Besides being a place of necessity, it was a place of culture (of sorts). Pictures and poems were pasted on the walls. — And there was plenty of reading material.

THE PRIVY

Probably Mom's greatest social embarrassment was our privy. Our farm friends knew all about these places of necessity and with them there was no need for apology. But for our town friends who were apt to find these facilities at best exotic and at worst, smelly and disgusting, Mom dreaded the visit of any guest who stayed long enough to need to go to the toilet.

Everything possible was done to make the place as socially acceptable as possible. The seats and the floors were scrubbed regularly with strong lye soap. In fact, that was one of our non-barn chores, on occasion. Mom decorated the walls with pictures and poems she had cut out of the *Saturday Evening Post, Good Housekeeping, Lady's Home Journal,* and *Wallace's Farmer* magazines. From the latter she clipped and pasted some humorous verse, "Song of the Lazy Farmer." One other poem she had clipped from somewhere, had the refrain, "Keep on keeping on," which somehow seemed fitting. There were also stacks of old magazines on a shelf to serve as reading material to help pass the time.

Out-of-date Sears Roebuck and Montgomery Ward catalogs furnished our "bathroom tissue." The thin paper pages, while not "squeezeably soft," were quite adequate. And after the Christmas holiday, the privy contained a box of discarded soft white wrapping tissue, which was quite a luxury.

In later years we sort of modernized our old privy by installing a roller for store-bought toilet paper. This upgrading helped a little bit to alleviate Mom's reluctance to have overnight houseguests.

However there was still the delicate issue of the chamber pot in the guestroom.

Absolutely the most detested chore on the farm was emptying the chamber pots (thunder mugs or whatever other name they went by) down the outside privy. I would much rather clean the cow barn gutter any time. My brother and I kept careful tab on whose turn it was to perform that distasteful task (cheating, if we could get away with it).

Good, bad or otherwise, the reality of our life was that we had to live with the presence of this uncouth facility all through our growing-up years. It wasn't until after the end of World War II and after we had left home that modernization finally came to rural areas. Then, a fine, modern bathroom, complete with an "indoor toilet," was established in our old farmhouse. One old farmer in our neighborhood balked at the idea of installing indoor toilets. To him it somehow seemed indecent.

The indoor facility was convenient and more comfortable, especially when compared to using the privy with a winter gale almost rocking us off our frosty seat and snow sifting through the cracks. But when it was no longer needed, there was a touch of sadness to see the old familiar structure torn down and its place covered over, all evidence of its presence having been obliterated. Only the vigorous growth of an ash tree on its spot attested to it having been there . . . a most fitting memorial to an old friend.

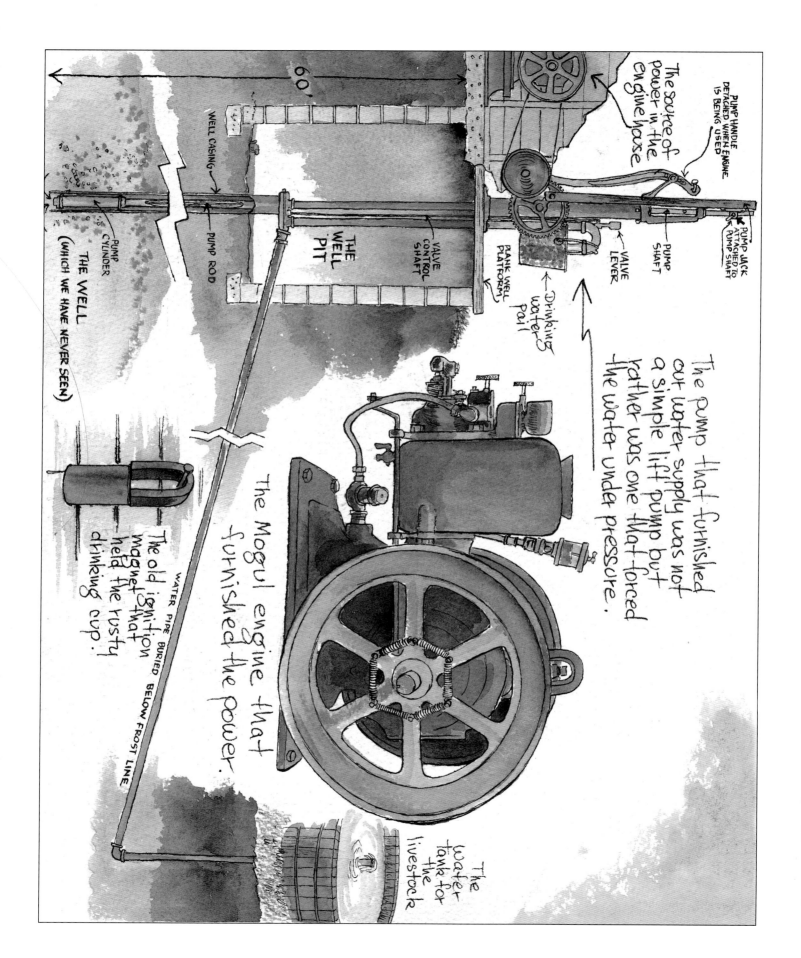

The source of power in the engine house

PUMP HANDLE DETACHED WHEN ENGINE IS BEING USED

PUMP JACK ATTACHED TO PUMP SHAFT

PUMP SHAFT

VALVE LEVER

PLANK WELL PLATFORM

←Drinking water pail

WELL CASING

PUMP ROD

THE WELL PIT

VALVE CONTROL SHAFT

60'

PUMP CYLINDER

THE WELL (WHICH WE HAVE NEVER SEEN)

The pump that furnished out water supply was not a simple lift pump but rather was one that forced the water under pressure.

The old ignition magnet that held the rusty drinking cup.

WATER PIPE BURIED BELOW FROST LINE

The Mogul engine that furnished the power.

The water tank for the livestock

WELL

Our well was drilled when the farmstead was established, sometime between 1900 and 1910, when the house was built. It was placed on the highest spot on the knoll that is the setting of the farmstead. This placed all drainage away from it.

I find it quite marvelous that the well, only sixty feet beneath the busy life of the farmyard, has never been seen by anyone. It is essentially a mysterious place that is the source of the life-giving water so necessary to all the animal and human inhabitants of the farmstead. And this mysterious place is reached only through a four-inch pipe casing that was driven down into it, through which the pump lifts the water to the surface. If for any reason (an earthquake?) that small tube between us and the well were pinched off, we would be without water.

I have no idea as to the extent of the aquifer that our well is a part of. I only know that in all of nearly one hundred years it has not faltered, even during drought, in supplying us with cold, potable water. Water quality tests have given it high marks.

There are those who do not like the slight mineral taste of the iron and lime present. But to one being raised on that cool, clear water, none other can match it as a satisfying thirst-quencher.

There were only two ways for us to get water out of the well: either by pumping the handle or, when a great quantity was wanted, like filling the stock tank, the combustion engine was used to run the pump jack. This one-cylinder, one-horsepower Mogul engine was started on gasoline, and then switched over to kerosene. The steady "putt, putt, putt" of its exhaust contrasted with the "chug-a-chuffer, chuffer, chug," of our larger Galloway gas engine we used for sawing wood and grinding feed for the animals. The latter was mounted on wheels in order to be pulled to where it was needed.

The sound of the rapid-fire exhaust of the Mogul told us that water was being pumped into the stock tank and that chore time had arrived. The Mogul engine was a dependable power source, as I remember, requiring little maintenance. Only seeing to its lubrication and fuel supply and the water level in its water-cooling jacket was about all it required, along with an occasional cleaning of the spark plug and points on the magneto. Its ignition was through a magneto. Its ignition was sparked by dry cell batteries, the same kind used in our wall-mounted telephone.

With the coming of electricity to the farm in the late 1930s, soon thereafter the Mogul was retired in favor of an electric motor to run the pump jack. We missed the sound of the Mogul's "putt, putt, putt" at chore time.

STOP— I THINK I SWALLOWED A WATER BUG! GULP

WELL, KEEP YOUR MOUTH SHUT THEN

ONE OF THE SEVERAL WAYS WE FOUGHT THE HEAT—AND ONE ANOTHER

YOU'LL HAVE THAT WATER SO ROILED THE CATTLE WON'T WANT TO DRINK

63

Along the railroad was one of the few places left where wild prairie flowers could be found.

It was exciting when the train came by— when we could afford it we put a penny on the rail to be flattened.

M AND ST. L RAILROAD

The branch line of the M and St. L (Minneapolis and St. Louis) railroad that cut through the fields about a half mile south of our place was a friendly presence in our neighborhood. Although it did not cross our land, it was very much a part of the environment of our farm.

Its melodic whistle, two long and two short blasts as it came to each crossing, announced its leisurely approach across the countryside. But aside from the blasts from its steam whistle, it made little disturbance to the peace and quiet of the neighborhood it was so much a part of, the only sound being a low rumble and clatter of its flanged wheels on the crooked rails, and the creaking and groaning of the swaying cars and the soft chuffing of its steam pistons. It never traveled faster than a brisk dog trot, which, considering the condition of the track, was a good thing. We were made aware of its twice-daily presence mostly by its unobtrusive sounds and, if the wind was right, the acrid, sulfuric smell of its coal smoke.

Even though we didn't know the names of the train crew, we had a waving acquaintance with them. They seemed as much a part of our population as the rest of our neighbors.

Sometimes we boys walked by way of the railroad when going to and from school. Since its twice-daily trips between Hampton, Latimer, Alexander, Belmond, and Kanawha, with its string of boxcars, stockcars, gondola, and tank cars, pulled by the steam locomotive and followed by the red caboose, did not

usually coincide with the time we'd be walking, it was safe to use this route. Once in a while, however, we were rewarded by the happy adventure of encountering the train. We would scramble up an embankment and sit in the grass to watch and wave to our unknown friends in the engine cab and the caboose as the train ambled by. Sometimes, if we thought we could afford it, we'd put a penny on the rail and then after the train had passed safely by, hurry down to retrieve our flattened, elongated trophy.

I didn't appreciate the fact then, like I would now, that this railroad land represented some of the last vestiges of virgin prairie in the state. But even though we weren't aware of the rarity of the native plants that grew there, we did enjoy the wild flowers and would sometimes pick a bouquet of those in season to take home to Mom.

The railroad right-of-way was an especially interesting place to explore. Not only did we find iron spikes, large nuts that had jiggled off a bolt, or a brace rod of one of the cars, but there was also a variety of interesting stones for our collections as well. These stones, of course, were from the ballast between the cross ties that had been hauled in for the roadbed. They, too, like the prairie specimen, were linked to the ancient past. They were quarried from a deposit left eons ago by the glacier.

In the fall, when the wild plum trees that grew along the right-of-way fence were loaded with juicy, sweet-tart fruit, we ate our fill and took some home in our lunch pails.

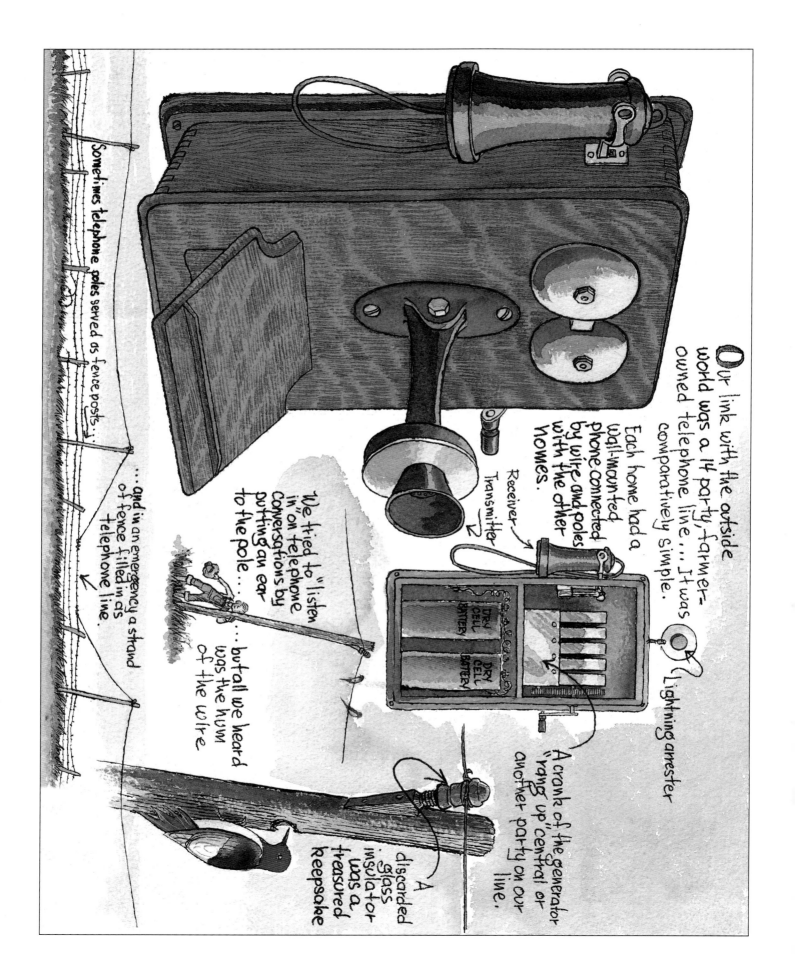

Our link with the outside world was a 14 party, farmer-owned telephone line... It was comparatively simple.

Each home had a wall-mounted phone connected by wire and poles with the other homes.

Lightning arrester

Receiver
Transmitter

We tried to "listen in" on telephone conversations by putting an ear to the pole....

....but all we heard was the hum of the wire

A crank of the generator "rang up" central or another party on our line.

A discarded glass insulator was a treasured keepsake

DRY CELL BATTERY
DRY CELL BATTERY

Sometimes telephone poles served as fence posts...

...and in an emergency a strand of fence filled in as a telephone line.

TELEPHONE

Dad smelled like cigar smoke when he came home from the telephone meeting. He didn't smoke but many others who attended the regular meeting of the locally owned telephone company did. It was nothing like a meeting of the big phone companies of today, but merely a group of neighbor farmers who owned our party line telephone system. At one time there were fourteen on our line. Each member was assessed fees in order to pay for the poles and telephone wire, etc. But each farmer owned his own phone set.

The farmer's line was connected to the telephone line in town, where "central" processed the calls and made the connections at the switchboard to put the caller in touch with the number requested. For instance, if Mom wanted to talk to Aunt Bertha, she would "ring up" central by vigorously turning the crank on the side of the phone cabinet. This crank turned a generator that sent an electric current through the wire, alerting the switchboard operator at the central office. She would say "Number please?" and Mom would give her Aunt Bertha's phone number, which the operator would then plug in to Aunt Bertha's party line and ring her number.

Each phone subscriber had its own ring. As I remember, ours was two shorts and a long. We would respond to our ring by lifting the receiver and yelling "Hello" (one had to yell in order to be heard). The only problem was every phone on our fourteen-party line would ring. It wasn't unusual, when picking up the receiver, to hear the click of several other receivers being lifted also. (One learned not to talk about personal things on a party line.) When we "rang up" central, that ring also was heard on all the phones on our party line. Then, too, we would hear several receivers being lifted.

One time, when I was in high school, I wanted to call up a girl to make a date for a movie. However, when I rang central and before she responded, I heard several clicks along our line. Not wanting an audience, I quickly hung up the receiver, deciding to try another time, when I was in town at the library where there would be a private line.

I wonder if the term "hung up," as in, "she hung up on me," didn't come from these old cabinet phones on which the receiver actually did hang on a bracket. When the receiver was lifted, the bracket sprang up, opening the line, but when you finished or wished to terminate a conversation, you hung the receiver on the bracket again—you "hung up."

There was a story of someone on a party line connecting the receiver to a loudspeaker so that when hearing someone's ring, a switch could be flipped so that eavesdropping could take place without interrupting supper preparation. This was before the radio "soap operas."

Understandably, Dad hated to talk on the phone and would go to great lengths to avoid it. One time he was repairing a farm implement in the yard when Mom called out to him that our neighbor, Walter, wanted to speak to him on the phone. Dad jumped into his car, which was parked nearby, drove a mile down the road into Walter's yard, and knocked on his back door to find him standing at his phone waiting for Dad to answer.

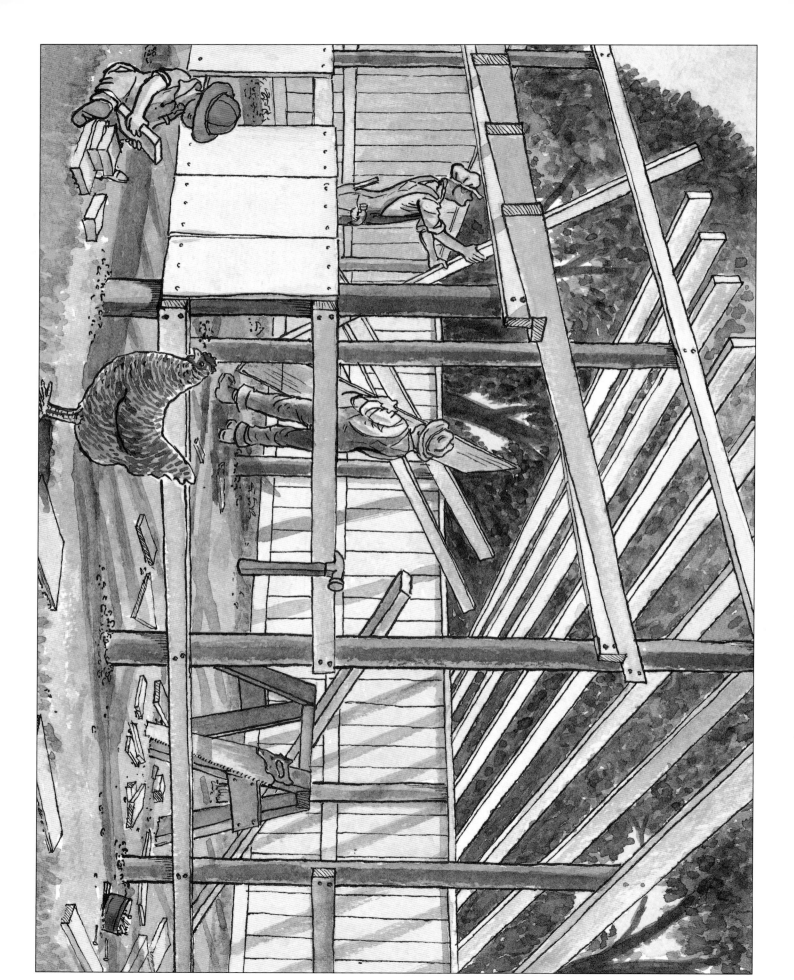

NEW CHICKEN HOUSE

After the corn had been laid by, in early July, and the oat harvest and threshing completed in August, there was a lull in the fieldwork. It was during this time that some took vacation trips or attended the county and state fairs. It was a time when the manure spreader was used again to haul manure from the barnyard feed lots and from the cattle sheds onto the fields of oat or hay stubble scheduled for fall plowing.

This lull between oat harvest and silo filling, the beginning of the corn harvest, was a time for special projects around the farm. Dirt was hauled to fill holes around the farmstead, and hayrack and wagon boxes were repaired or built anew, as were gates and barn doors. It was also a time when needed cement work was done.

One August, we helped Dad build our new chicken house, so that we might increase our flock capacity over what it had been when housed in the lean-to on the east side of the granary. The site was leveled with horses and slip scraper. With shovel and spade and posthole auger, holes were dug and creosoted poles were set in the ground. To these poles were nailed timbers making a framework to which foot-wide vertical pine boards were nailed for siding.

We enjoyed building this improvement to the farm. We liked working with the fragrant new lumber, using the few hand tools we

had. Dad had designed the building, making rough pencil sketches on scraps of the smooth pine boards we were using as siding.

Over the two-by-four and two-by-six inch rafters were nailed ship-lap boards, on top of which we spread tar paper as a base for the composition shingles with a green-tinted, finely crushed rock coating. Four-pane barn windows were bought at the lumber yard for the two rows of windows on the south side of the building—one row at the top (in the clearstory) and the other low down. These two rows of windows would allow the low-angle rays of the winter sun to flood the interior with its warmth.

Along the two end walls, in the front half of the chicken house, we made two tiers of nests for the egg layers. Along the north half, from end to end, about three feet above the floor, we built roosts, using two- to three-inch-diameter willow poles we had cut from trees at the creek.

It was with a great sense of accomplishment that we all stood back and admired our completed chicken house with its fresh coat of barn-red paint. That night, Mom, Dad and we boys with lantern and chicken hook carried the squawking hens and roosters from their old place to their new one. When the morning light came, we hoped they liked their new home.

THE "BLUE PRINTS" WERE PENCIL SKETCHES ON SCRAP PINE BOARDS

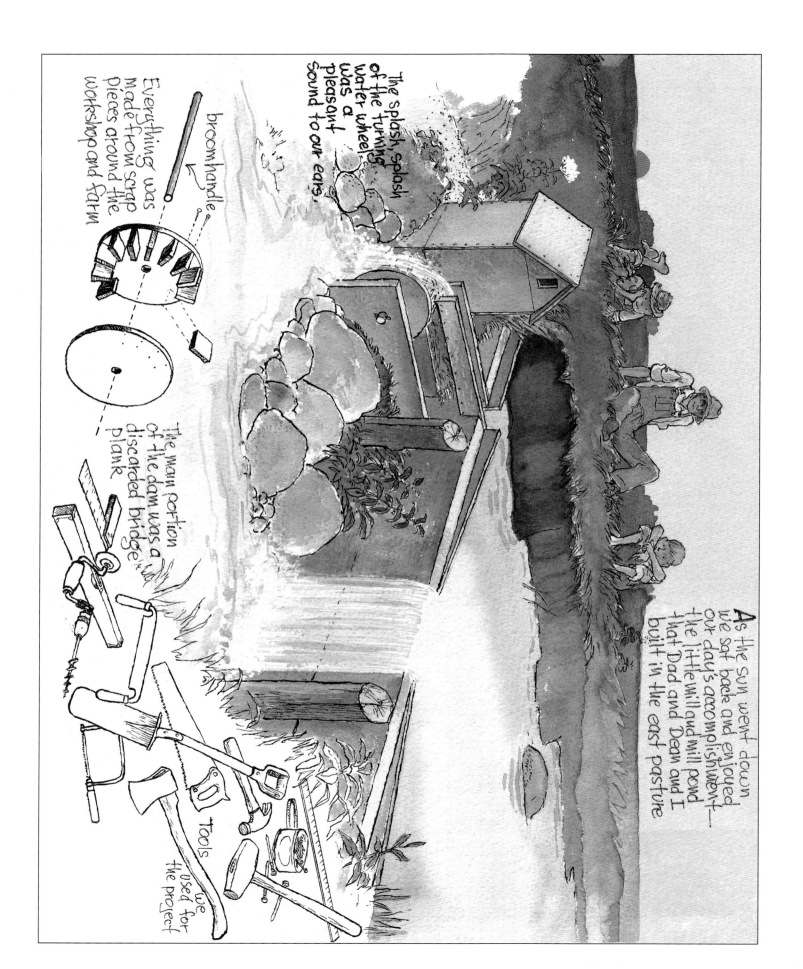

The splash, splash
of the turning
water wheel
was a
pleasant
sound to our ears.

broom handle

Everything was
made from scrap
pieces around the
workshop and farm

The main portion
of the dam was a
discarded bridge
plank

Tools we
used for
the project

As the sun went down
we sat back and enjoyed
our day's accomplishment—
the little will and mill pond
that Dad and Dean and I
built in the east pasture

THE MILL

On the east border of the farm, a neighbor's field drainage tile emptied into an open ditch in the east pasture. This small stream meandered southwestward to a stand of randomly spaced old willow trees along the edge of the low knoll where Grandpa Amos had built his little house long ago. It proceeded southward, fed by several springs, through a swampy area of reed and cattails until it flowed into Spring Creek, flanked by more gnarled, ancient willows.

It was a beautiful Sunday morning in late August when Dad, Dean, and I, having eaten a hearty breakfast, bid Mom and baby brother Dan goodbye, picked up our packed lunch for our noon meal, and set off for the east pasture. With great anticipation for the day's project ahead we strode down the hill from the farmyard and along the sun-warmed, dusty two-track field lane. The weather was perfect for doing what we had planned.

The previous evening we had delivered, by horse and wagon, some large planks and other scrap boards, posts, and tools needed, to the spot we had chosen along the small brook just a few yards from where it began on the border of the east pasture. Included in that delivery was the little mill and waterwheel that Dad had previously made for us in the workshop.

Working with Dad was nothing new to us. One of the benefits of living on a family farm was that of parents and children being able to work together. It was through this everyday association that life's principles and sense of values could be learned simply by observation and shared experience. I don't recall being "preached at" concerning living a good life, but we did have everyday living examples to try to follow. So while working with Dad was not new to us, the fact that our work this day was for a fun project made it extra special.

It was a perfect summer day for outdoor activity. The sun was warm but the air dry and easy to breathe. The songs of the meadowlarks, killdeer, redwing blackbirds, and song sparrows made a pleasant background to our work.

We dug the trench on either side of our dam site in which to imbed the planks that were to form the dam. We set the posts supporting the dam on the downstream side, and gathered boulders and smaller stones, piling them against the dam for support. All of this work was done while straddling the little stream that was allowed to flow uninterrupted until our work on the dam was complete. Then, with chunks of sod, we began to block the flow under the dam. More sod and soil and rocks were added until the flow was completely stopped and water began to slowly rise behind the dam.

While the millpond was filling, we turned our attention to the little mill and its waterwheel. We cut a notch in the top of the dam and fashioned a flume through it, over the waterwheel. With our project completed we sat on the grassy bank and watched the water creeping up its impoundment.

As the sun set, water began to first trickle and then flow through the flume and splash onto the waterwheel and then turn it as we had intended . . . a satisfying end to a beautiful day.

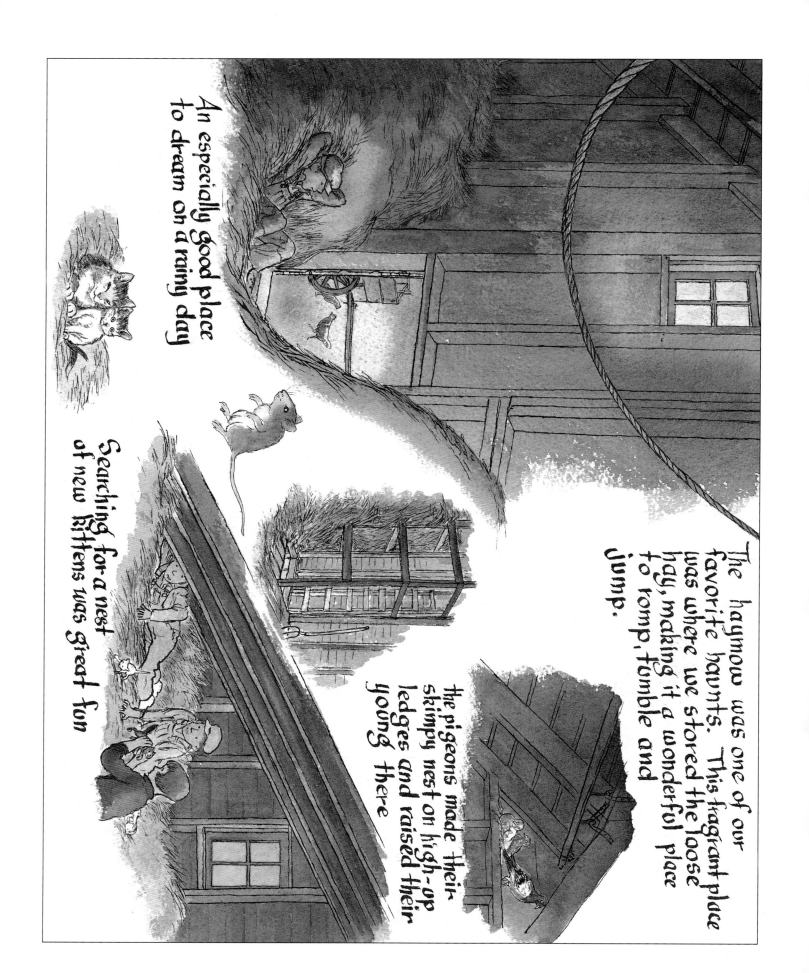

The haymow was one of our favorite haunts. This fragrant place was where we stored the loose hay, making it a wonderful place to romp, tumble and jump.

An especially good place to dream on a rainy day

Searching for a nest of new kittens was great fun

the pigeons made their skimpy nest on high-up ledges and raised their young there

HAYMOW

The barn was my favorite farm building, and the haymow was my favorite place in the barn. Of course, work was associated with that dusky, fragrant place. At least once a day we had to climb the ladder into the mow and throw down hay for the horses or cows. This is also where we stored oat straw for bedding for the livestock below. And who could forget the hot, suffocating, muscle-wrenching work of distributing the new hay around with pitchforks in the dust-laden air of the loft during hay-making season.

But most of the time the haymow was a quiet pleasant place to be alone and dream, particularly on a rainy day. Or it could be a place full of fun-filled activity, as we kids could roughhouse, tumble and swing on the hay rope, and jump into deep piles of loose hay.

During the quiet times, we would hear the muttering of the pigeons high up in the rafters. Sometimes we would climb up to inspect, but never disturb, their meager nests on high ledges. This aggressive-appearing action would cause a frantic flapping of wings as they made their escape though the open window high in the peak of the barn.

The haymow was where our barn cats lived and multiplied. It was great fun to go looking for a nest of new kittens when we noticed that the very pregnant mother cat was suddenly slab-sided, when she came down at milking time to lap milk at the cat dish. Mice also were residents of the haymow, where there was plenty of nesting material and hayseeds to feed upon. There was also a whole bin of oats downstairs, and spilled grain around the mangers. So the mice had a good life if they didn't run afoul of the cats, with whom they had an uneasy coexistence.

I used to think I would like to sleep overnight in the haymow,

bedded down in the fragrant hay, listening to the sounds of the night and the winds sighing through the cracks and around the corners of the barn. I thought that would have been very cozy, as long as brother Dean would have been there too. But our parents never gave their permission. I think they were afraid of the possibility of fire.

Fire was a constant concern, especially after seeing a barn about two miles west of our place, in which two calves were trapped, burn to the ground. This fear of fire prompted Dad to refuse the requests of hobos, who now and then stopped by to request to stay overnight in our barn. This was especially so if he smelled tobacco or liquor on them.

73

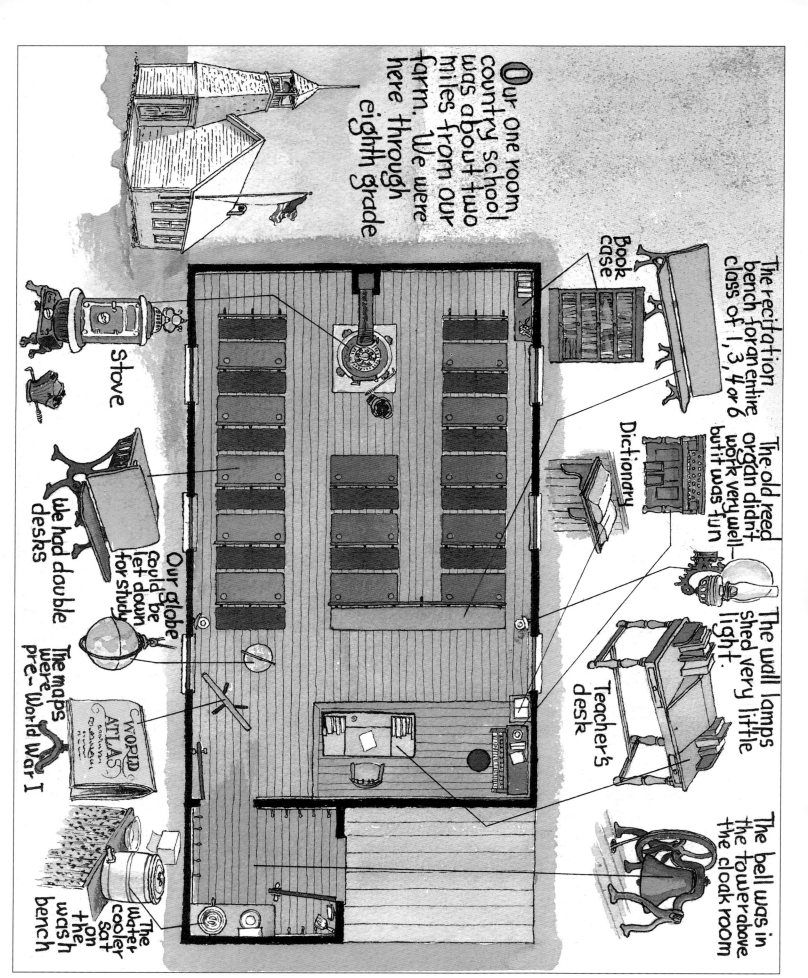

Our one room country school was about two miles from our farm. We were here through eighth grade

Book case

The recitation bench for an entire class of 1, 3, 4 or 6

The old reed organ didn't work very well—but it was fun

Dictionary

The wall lamps shed very little light.

Stove

We had double desks

Our globe could be let down for study

The maps were pre–World War I

Teacher's desk

The bell was in the tower above the cloak room

The water cooler sat on the wash bench

AUTUMN
SCHOOL

Regardless of what the calendar said, the end of summer and the beginning of fall occurred on the first day of school.

We usually walked the two miles from our place to the one-room country school we attended through eighth grade. If the weather was inclement Dad, took us in the car. If the roads were bad in the winter, it was by wagon or bobsled.

On fine autumn days and spring days, the walks to and from school were pleasant, sometimes even enjoyable to the point of making us late getting to school or home in the evening. There were so very many interesting distractions along the way: bird's nests, turtles, badger and groundhog dens, and all the denizens of the creek and slough we encountered along the way.

The first day of school each year was good and bad, The good was seeing our schoolmates again and taking up where we had left off on the last day of school in the spring. The bad was sizing up and getting acquainted with the new kids or, heaven forbid, a new teacher!

But mostly our school experiences were positive ones. There were schoolyard disputes of course, and the occasional fight. There were confrontations with Teacher now and then, but these were mild, usually dealing with a lesson not completed or directions not followed. I don't ever recall serious disciplinary problems involving corporal punishment. Staying in at recess maybe, or after school, but nothing like the spankings or slappings that we used to hear about.

Grades one through eight were taught by our one teacher. There was seating for twenty-two pupils, but I think the most we had at a time while I attended was fourteen or fifteen.

Each season during the school year had its special pleasure to

anticipate. Halloween, Thanksgiving, Christmas, and Easter were duly commemorated by at least posters and other handmade decorations for windows and walls. We had at least one school program during the year, to which all in the district were invited, where recitations were given, songs sung, and skits presented.

These programs were usually to recognize Halloween, Thanksgiving, or Christmas. There were also occasional box socials at which decorated boxes of lunch were auctioned and then shared by the buyer and the secret provider of the box. These socials were enjoyable or agonizing, depending on who was pared with whom.

Taken in balance, our country school experience was good and added much to our growing-up years. The shared values learned there went beyond what we learned from our books.

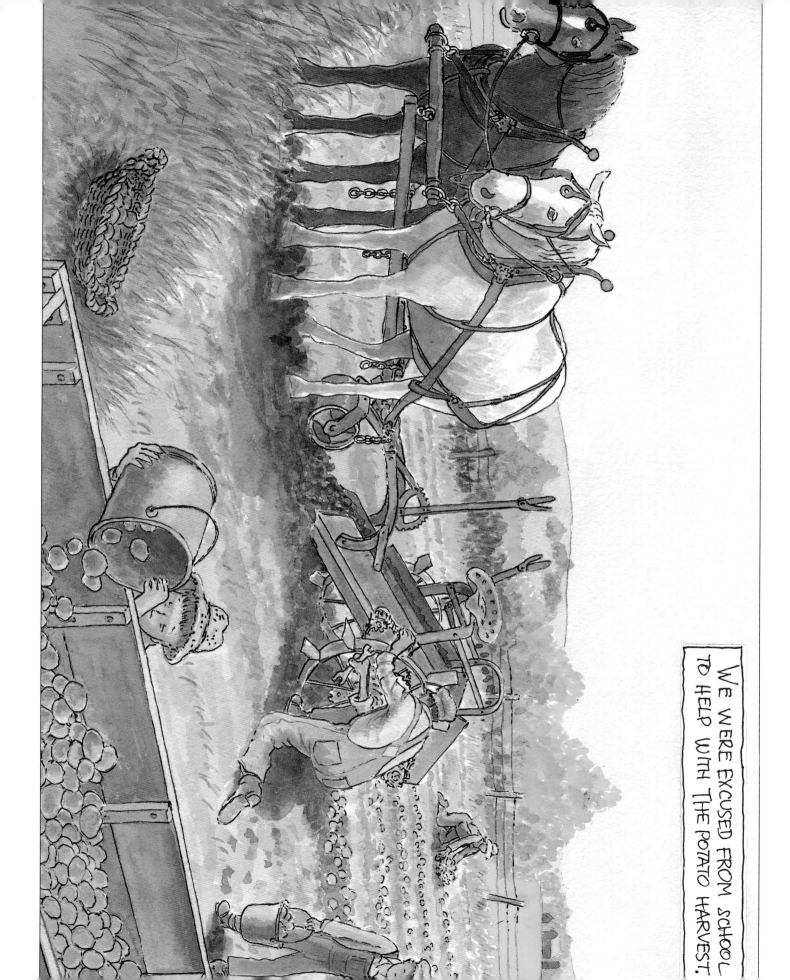

WE WERE EXCUSED FROM SCHOOL
TO HELP WITH THE POTATO HARVEST.

POTATO DIGGING

The potato crop on our farm was not on the same scale as that of corn, oats, or hay, but it was an important crop. It was our food staple. Early in the spring (tradition said potatoes should be put in the ground on Good Friday, in that phase of the moon), we went to the cellar and scooped up a basket full of the dormant tubers and brought them up into the yard and dumped them in a pile. Sometimes cutting potatoes became a family project. Perched on boxes or overturned bushel baskets, with pocketknives and paring knives, we would cut potatoes. We aimed to have at least two eyes in each cut piece.

After the soil had been prepared, a furrow was made in the soft loam and the cut pieces were dropped into it, spaced about fifteen inches apart, before being covered in the row. All spring and summer the potato patch was kept hoed free of weeds. Also, there was the potato bug that had to be dealt with. We had to go up and down the rows with a tomato can about half full of kerosene, and with a little wooden paddle, knock the offending beetles off the lush, green plants into the kerosene. At the end of the row the collection of soaked bugs was dumped in a pile, where they were later burned.

To show the importance of the potato harvest in our farm culture at that time, school kids were readily excused to help when it came time to dig potatoes. It was usually a family affair, with Dad driving the team on the old iron potato digger, and the rest of us, often including Mom, picking up the succulent tubers as they dropped to the ground behind the clattering old machine. A wagon hauled the earthy crop to the house, where it was

THE ENDS OF THE TINES OF THE **POTATO SCOOP** WERE ENLARGED AND BLUNTED IN ORDER TO LESSEN THE CHANCE OF THE SUCCULENT TUBERS BECOMING IMPALED UPON THEM.

unloaded down a chute through a cellar window into the potato bin for winter storage. From this bin, potatoes were selected all winter long up until next year's harvest, for all the many ways that versatile food was prepared: boiled, fried, baked, mashed, scalloped, made into soup and salads, and combined in stews and roasts.

A typical potato digging day in September was balmy and sunny, with a gentle breeze moving the air from the southwest. Riding on this breeze were the tiny parachutes of thistle and milkweed seeds and spiders riding on long strands of gossamer they had spun for that purpose. Often this mellow day followed a frost that had nipped the foliage in the surrounding fields, producing a nut-brown fragrance that mingled with the faint scent of smoke from grass fires somewhere.

All in all, potato-digging time was a pleasant, golden September day.

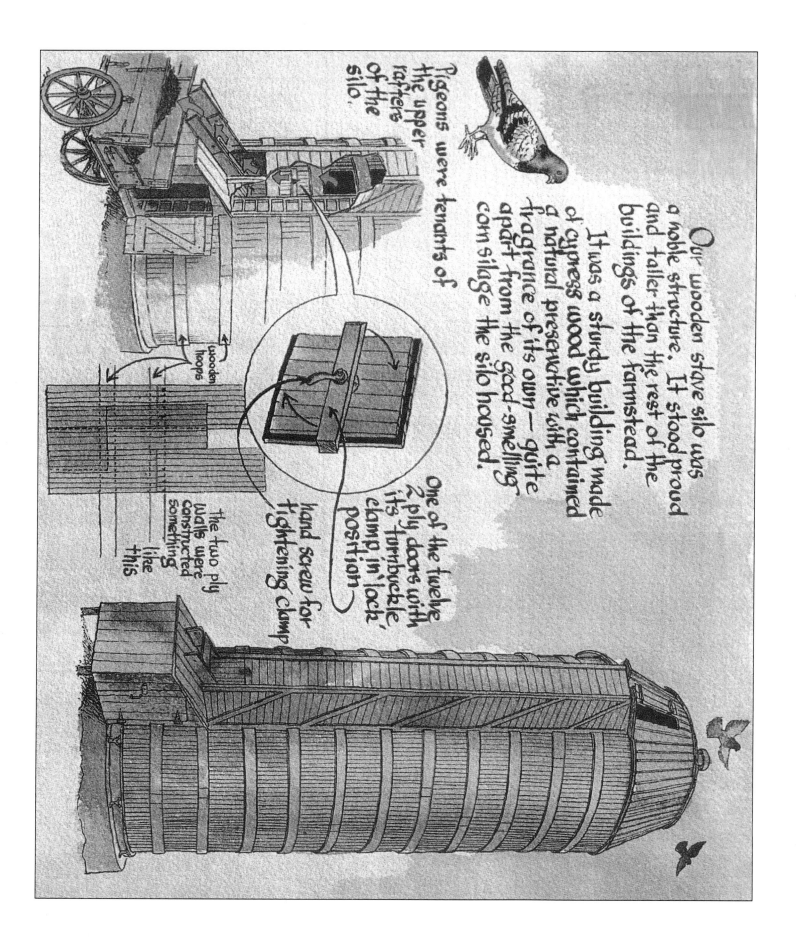

Our wooden stave silo was a noble structure. It stood proud and taller than the rest of the buildings of the farmstead.

It was a sturdy building made of cypress wood which contained a natural preservative with a fragrance of its own — quite apart from the good-smelling corn silage the silo housed.

Pigeons were tenants of the upper rafters of the silo.

wooden hoops

the two ply walls were constructed something like this

hand screw for tightening clamp

One of the twelve 2 ply doors with its turnbuckle clamp in 'lock' position

SILO FILLING

The silo on our farm was a noble structure. It stood taller than any building on the place, catching the first beams of the morning sun and the last golden rays as the day came to an end. It was sturdily built of cypress wood, resistant to weather and rot and the acids of the fermenting silage. Its unpainted surface assumed a soft silver-gray patina that added to its dignified image.

In about mid-September, when the corn had matured but the stalks still contained juice, it was chopped and put into the silo. Counting the potato harvest, this was the fourth of the season. It was silo-filling time.

As with threshing, silo filling was a cooperative effort among those in the area who had silos to fill. On chilly mornings when a light frost coated the fields and farmyard, a frost that was soon melted away by the bright autumn sunshine, fodder racks mounted on wagons began to gather.

A horse-drawn corn binder went to the field first, cutting and binding the standing corn and dropping the heavy, green bundles to the ground where they were picked up, loaded onto the wagons, and hauled to the ensilage cutter that had

been set up along side the silo. Blower pipes, about eight inches in diameter, were attached to the ensilage cutter and were extended up to the top of the tall silo. As bundles of corn were fed into the machine, sharp blades cut them into small pieces and the powerful blower, which was run by a wide belt from a gas or steam tractor, forced the mixture of chopped corn stalks and ears up into the silo.

Sometimes, if the corn stalks didn't contain enough juice, water was added to the chopped mixture to help promote the fermentation process. Also to help with the ensilaging of the chopped fodder, someone (one of my earliest silo filling jobs) tromped around on it, leveling and packing it down to help eliminate air pockets.

As the column of chopped corn rose higher in the silo, the access doors were put into place and locked and sealed with wet clay that had been brought up from the creek. This, too, was one of my early jobs at silo filling.

After the silo had been filled and the equipment dismantled and taken away, the ensilaging process was permitted to take place within the structure. This process gave off a peculiar odor, a poisonous gas. We were all warned not to enter the silo for several days, until the ensilaging process was completed. Accounts were told of people who had suffered a quick death by going into the silo and breathing the oxygen-robbing gas.

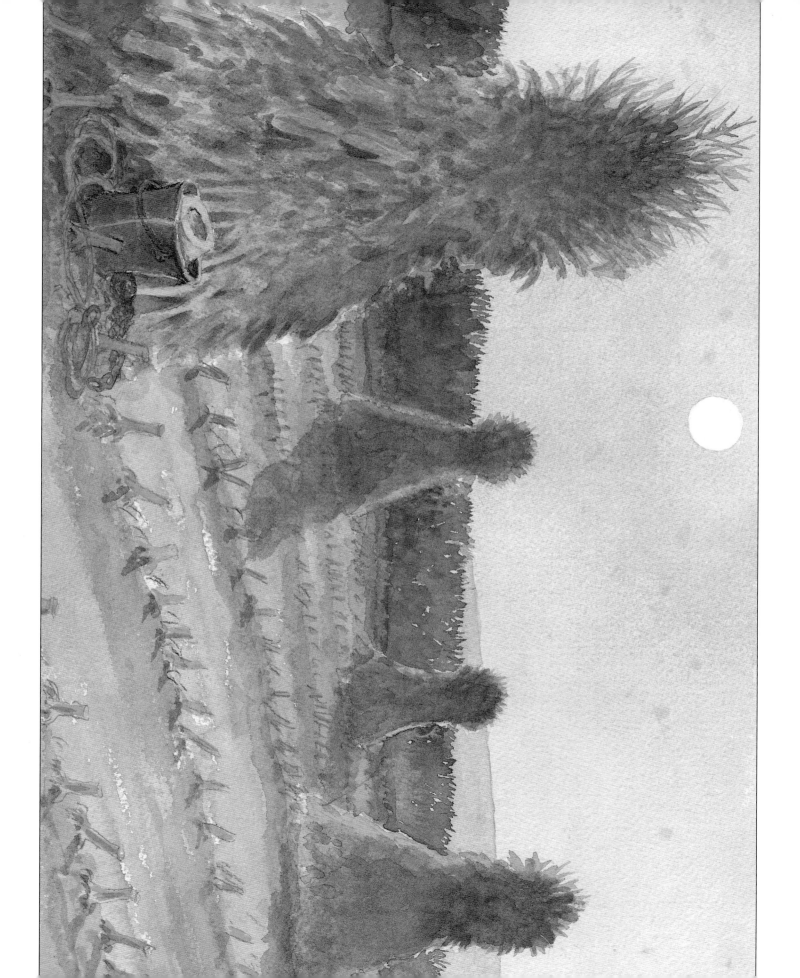

CORN SHOCKS

The bucolic scene of a field of corn shocks, rare now, was a common sight even as late as the 1930s and 1940s. After the standing corn crop had fully ripened, the dry leaves rattling in the breeze and opened husks revealing the hard yellow ears within, the corn binder was again brought to the field.

The moisture that had been desirable for making corn silage had now gone from the corn stalks. The horse-drawn corn binder was driven back and forth across the field, one row at a time, cutting and binding the stalks into bundles. These bundles were dropped from a carrier on the binder into windrows. From these windrows we gathered the bundles and sat them up into the familiar tipi-like shocks.

Dad and my brothers and I used to work together at this slow, backbreaking task, the companionship making the work even pleasant at times. However, when we boys were in school, Dad had to do the job alone. He made a "shock horse" (not a "saw horse") which helped to hold the first few bundles upright.

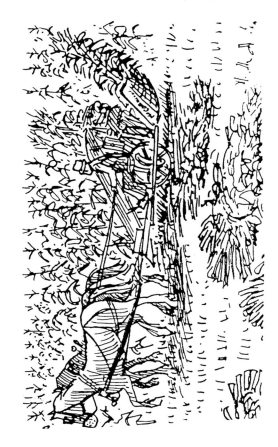

When the shock of ten or twelve bundles wascompleted, the "horse" was pulled out and used for starting the next one.

After a field of shocks was set up, a stout length of binder twine was wrapped around the shock and pulled tight with a block and tackle and then tied. Properly set up and tied in this way, the corn shocks could withstand the autumn and winter storms, thus preserving the fodder until it could be hauled from the field and stacked near the feed lot.

Sometimes these corn shocks were converted into shredded corn fodder. The farmers came together to shred corn, the same as when threshing oats. The corn bundles were hauled from the field and fed into the mouth of the shredder. This marvelous machine, like the threshing machine, separated the grain from the stalks and chaff. Husking rollers removed the whole ears from the stalks and delivered them into a wagon to be stored in the corncrib. The more corn we harvested this way, the less we would have to pick by hand.

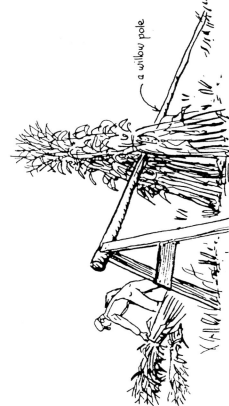

a willow pole

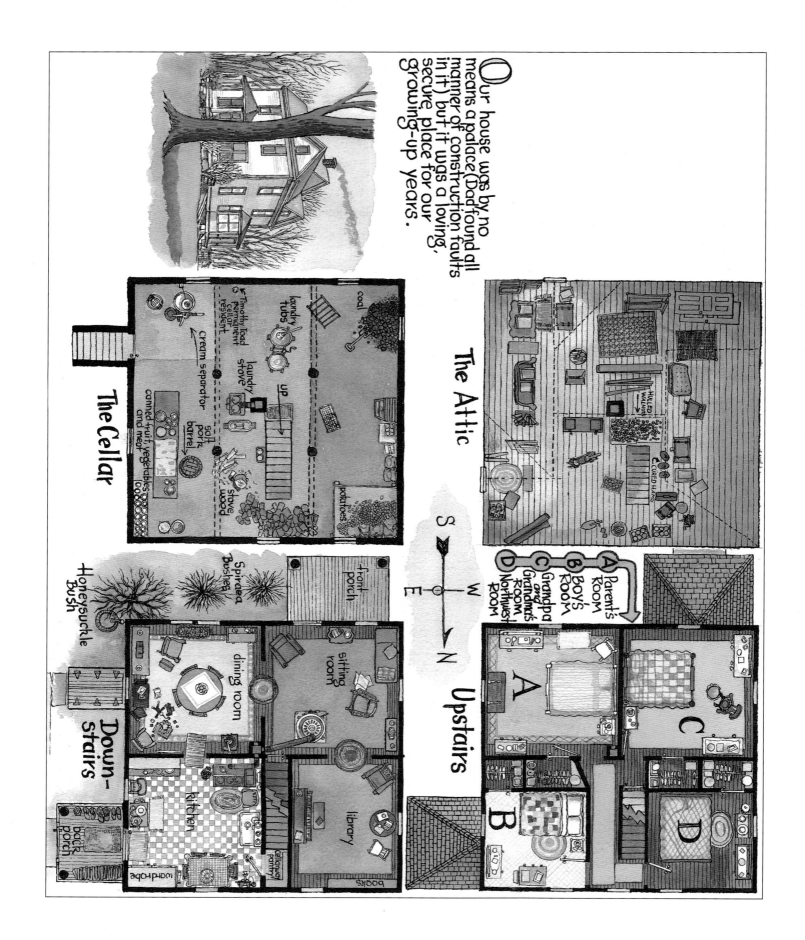

Our house was by no means a palace (Dad found all manner of construction faults in it) but it was a loving, secure place for our growing-up years.

The Attic

The Cellar

HULLED WALNUTS

CURED HAMS

Timothy Toad permanent cellar resident

laundry tubs

laundry stove

cream separator

salt pork barrel

stove wood

canned fruit, vegetables and meat

potatoes

coal

UP

A — Parents' Room
B — Boys' Room
C — Grandpa and Grandma's Room
D — Northwest Room

S
W E
N

Upstairs

A

B

C

D

Downstairs

Honeysuckle Bush

Spiraea Bushes

front porch

dining room

sitting room

library

books

kitchen

wardrobe

cellarway pantry

back porch

THE HOUSE

Our square, two-story, white farmhouse, with a dirt-floor cellar plus a walk-up attic, was where my two brothers and I were born and raised. Dad found all manner of construction faults in the house. It had been built during severe winter conditions of 1910. Those adverse circumstances, and the sloppy workmanship of the contractor, produced many serious construction flaws that didn't come to light until spring, when my grandparents were finally able to drive the several miles from their home over muddy roads to inspect the new house.

The contractor was made to return and fit supports under the sagging new structure so that doors could be opened and closed, but the damage had been done, producing cracked plaster and doorframes that remained out of alignment.

For the next few years, until Dad was ready to take over his inheritance, the farm was occupied by a succession of renters.

Typical farmhouses of its time, it had no electricity, indoor plumbing, or central heating, so our mother's task of keeping house was not easy. However, with much effort, dedication, and love, and with Dad's help, Mom made a cozy, secure home for her family to grow in and to return to often in years to come, for as long as she lived there.

Except for the occasional stranger not acquainted with country ways, visitors entered the house into the kitchen through the enclosed back porch.

The first floor consisted of four roughly square rooms: kitchen, dining room, living room, and library. The stairway door off the living room lead to the second floor of four bedrooms with walk-in closets. Off a second floor hallway, a door opened to steep stairs into the attic, a wonderful place to be on a rainy day. We kids liked to explore its dark nooks and crannies under the sloping eaves and to examine the contents of the old trunks stashed there. One of the good things about the attic was its pervasive smell. Sometimes we liked to just open the attic door to get a whiff of that nostalgic odor.

The two large front bedrooms were occupied by my parents and grandparents. My younger brother Dean and I slept in the northeast bedroom. When little brother Dan was old enough to leave his small bed in our parent's room, there was a major shifting of occupancy. Grandma and Grandpa moved downstairs to the library that doubled as a bedroom. Then we three boys each had a room of our own upstairs and Grandma and Grandpa didn't have to climb the stairs.

The kitchen, as far as I was concerned, was the heart of the home. That was where Mom could usually be found when we came home from school, plopping down our books and lunch buckets and going directly to the cookie jar or to where fresh ones were cooling just out of the oven. It was also to the kitchen that visitors seemed to gravitate for conversation or to accept some proffered refreshment.

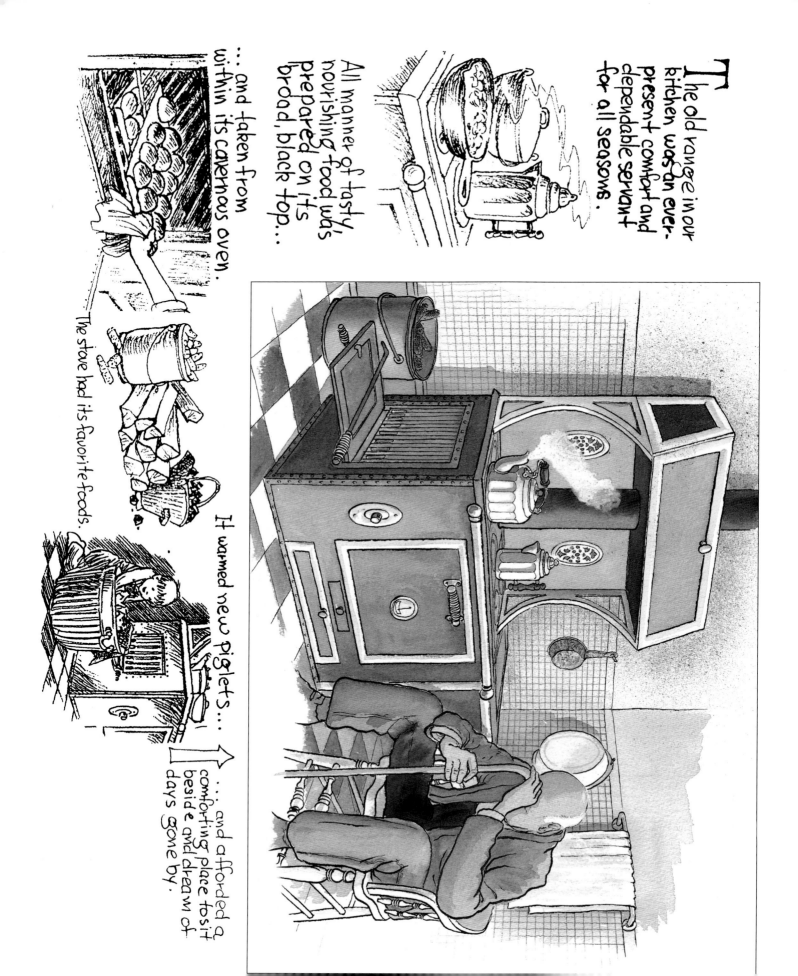

The old range in our kitchen was an ever-present comfort and dependable servant for all seasons.

All manner of tasty, nourishing food was prepared on its broad, black top...

...and taken from within its cavernous oven.

The stove had its favorite foods.

It warmed new piglets...

...and afforded a comforting place to sit beside and dream of days gone by.

THE KITCHEN RANGE

The big black range, with nickel trim, was a friendly presence in our kitchen. It cooked our food, baked our bread and pastries, and heated water for us in its copper-lined reservoir. In the winter, it was in front of the warmth of the range that we took our baths in the big laundry tub, carried in for the occasion.

If the kitchen was the heart of the home, the range, with Mom's directions and close attention, was the warmth of that heart. If the fire was allowed to go out and the range grew cold, the kitchen was literally and figuratively without warmth. In fact, during the summer, when the cooking was done on the kerosene stove and the portable stove-top oven was used for baking, and the range top had newspapers spread on its cold top and was used as a countertop, the kitchen was lacking in its ambience.

But during the cold months, the range was what we sought out when coming into the kitchen. The nickel-plated, copper-bottom teakettle was usually steaming on the black top. Near mealtime, skillets and kettles and the coffeepot would be emitting their fragrances of the meal being prepared.

From the large oven all kinds of wondrous food came forth: homemade bread, buns and cinnamon rolls, cakes, pies, cookies, baked puddings, and roasted meat of all kinds. Of course Mom had something to do with all of this good stuff, and could always be found there ministering to the needs of the range . . . and us.

The warming oven over the back of the range, meant for keeping food warm until it was served, was where we kept our mittens so they would be warm when we wore them out into the cold.

During a cold snap at farrowing time, it was not unusual to see Dad massaging a stiff, blue little piglet in front of the open oven door, until its small body turned a warm pink and it began to wiggle into life and emit little grunts and squeals. And quite often a basket of cold piglets was kept behind the range, with a burlap sack over them. As they warmed and became lively, it was hard to distinguish the sound of their tiny grunts from that of the percolating coffeepot on the stovetop.

The range, along with the living room stove, helped to keep us warm against the winter cold. But in providing these services there was a price to pay—we had to keep it fueled with corncobs, wood, and coal, and its reservoir filled with water carried from the well. Its grates had to be cleared of clinkers and ash and its flues kept free of soot. It was well worth the cost.

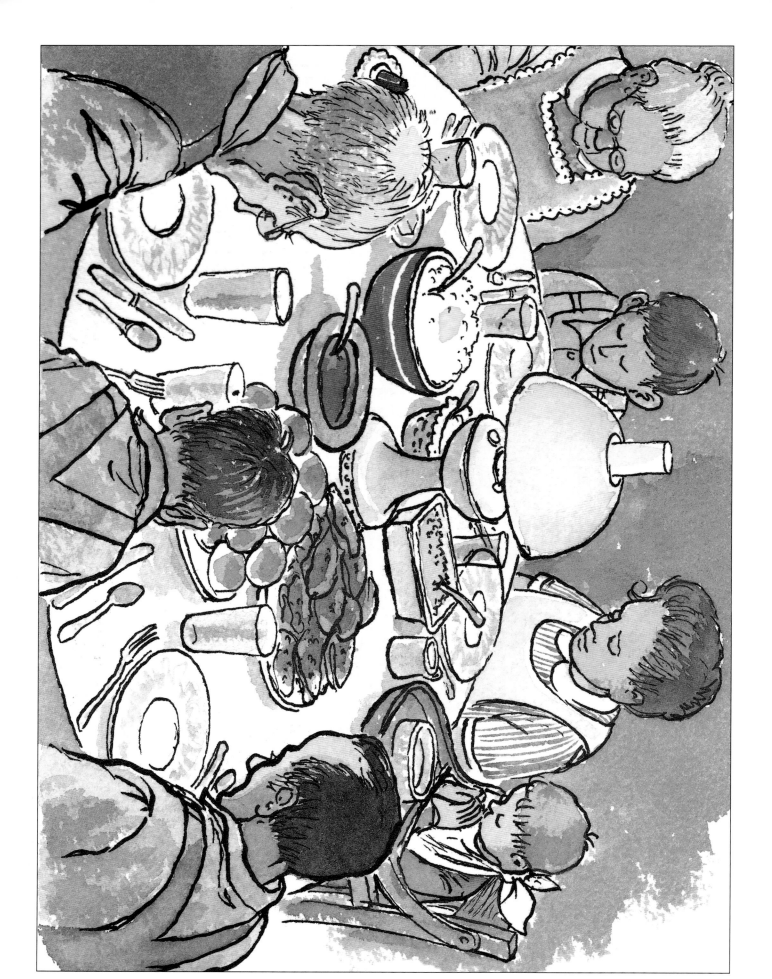

THE SUPPER TABLE

Practically all of our meals (breakfast, dinner, and supper) were family affairs around the table. Thanksgiving dinner was a special feast we looked forward to with salivating pleasure, when the meal was shared with relatives. It truly was a time to give thanks.

However, thanks was given at every meal at our house. Either Dad or Grandpa asked the Lord's blessing and expressed thanks for the food of which we were about to partake. In fact the table blessing was so much a part of our lives that to be present at a table where the prayer was omitted left me feeling as though something vital was missing from an otherwise pleasant, tasty meal.

When Grandpa and Grandma Crow were with us, we took our meals around the large round oak-veneer table in the dining room. This table, where we ate with our guests when there were more than could be comfortably seated around the kitchen table, was capable of being extended to seat twelve people. This also is where threshers and silo fillers ate, when working at our place.

Some of my earliest and also warmest memories of growing up were of those good times spent around our table at mealtime. Supper was my favorite meal. This was at the end of the day, when we each contributed to the conversation—bits from the day's activities at school or around the farm. Here we discussed topics from local, national, or world news. Our supper table sessions were especially enjoyable when Grandma and Grandpa were with us. Grandpa would relate his experiences as farmer, buggy maker, and deputy sheriff. Grandma put in a word now and then to jog Grandpa's memory. He had a real talent for storytelling and we enjoyed hearing those same stories over and over. We laughed repeatedly at the hilarious situations he related, lingering around the table long after the meal was finished.

In addition to the kitchen and dining room, the two front rooms were a part of our everyday living area. The living room during the heat of summer was characterized by the front door and windows being opened wide, permitting whatever breezes were stirring to whistle through the screens. Since we had no electricity we had no fans but relied on nature to move the air for us. I remember how, after our noon break for dinner, we'd stretch out on the living room floor for a short nap before going back into the heat of plowing corn, making hay, or shocking oats.

In the cold winter months, however, the front door was virtually sealed, in order to retain as much heat inside the house as possible. The screens were taken off and replaced with storm windows.

Reprinted from Christmas: *The Annual of Christmas Literature and Art*, Volume 56, copyright © 1986 Augsburg Publishing House. Used by permission of Augsburg Fortress.

Elbow

Stove pipe

Chimney flue

The flue stopper for when the stove was taken down for the summer.

All of this had to be carried in...

...and this carried out

Our livingroom stove was not as fancy as some we knew, but it was a friendly presence the family gathered around for cozy evenings during the long cold season.

VERONA

THE LIVING ROOM STOVE

In the late fall and in the spring, seasonal changes were marked by putting up or taking down the living room stove. We rejoiced with each occasion. In the fall it was for the cozy evenings that lay ahead and in the spring it was for the end of the confining cold and the promise of warm days and a new life.

When the living room stove was brought in from its summer storage and very carefully handled so as not to jar or loosen any old soot or ash onto the floor, the furniture was rearranged to make room. The metal-sheathed insulating pad was put on the floor and the stove positioned directly on it. Then the flue pipes were carefully aligned, with one end attached to the stovetop and the other inserted into the flue opening in the chimney.

In the event an unusually cold season had come early, before the living room stove was in operation, we were confined to the kitchen, where the fire in the range kept us warm. So it was with a sense of more expansive living when the first fire of the season was crackling in the living room stove.

One of the early sounds to awaken us in our very icy bedroom upstairs on a winter morning was the clanking noises downstairs as Dad shook ashes out of the grate and stirred the banked coals into life and added fresh fuel. We kids would wait until we thought the living room was reasonably warm before grabbing our clothes and dashing downstairs to dress around the revived fire in the stove. The trick was to get close enough to absorb the stove's heat without accidentally letting our bare skin come into contact with the hot stove surface.

The smell of the hot iron and the loud popping and pinging sounds of the expanding joints of the stove as it heated up were all a part of those early mornings as we dressed. The heat from the living room stove spilled over into the library and made it possible to enjoy that room in comfort, exploring the books on the shelves.

Neither brother Dean nor I could play the old piano that stood in the library, but Mom would sometimes pick out some favorite tunes on it. Later Dan was given piano lessons and practiced on the old instrument.

Dean practiced his horn there. The year he graduated from the eighth grade in country school our parents bought him a cornet and had him take lessons so that he could join the band when he started high school.

It was the cozy ambiance created by the soft light of our kerosene lamps and the warmth from our kitchen and living room stoves in those long winter evenings, spent in these rooms, reading, playing board games or carom, and eating popcorn and apples, that we looked forward to.

The best treat of all was when Mom read aloud to the whole family. We could hardly wait to finish our chores, supper, and homework, so that Mom could continue where we'd left off the evening before, in *Robin Hood*, *Swiss Family Robinson*, *Ivanhoe*, or *King Arthur*. It was in these rooms also, throughout the year, usually on Sunday mornings when we didn't get in to Sunday school and church, that we became familiar with stories from the Bible.

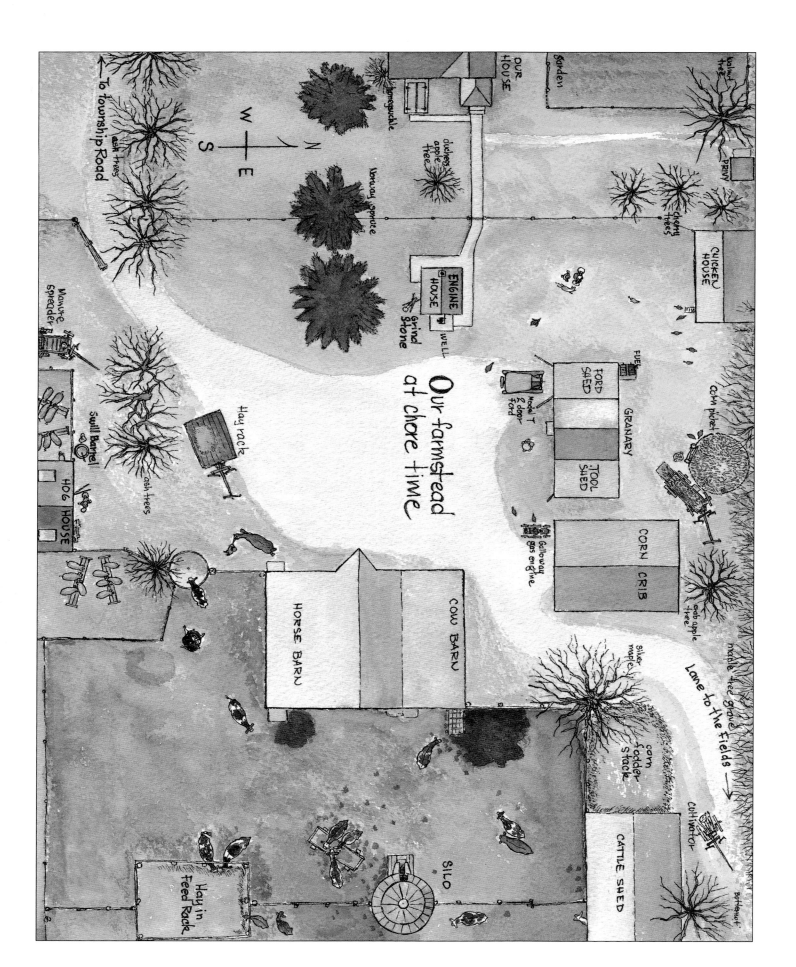

CHORE TIME

Chores on the farm were almost a ritual, performed morning and night, seven days a week, fifty-two weeks a year, including holidays. If one viewed it negatively, chore time was almost like a life sentence. I must admit, there were times when I did see those inescapable chores in a negative light, but when very young, I often dreamed of being "grown up" so I could take part in the fascinating work of chores that Dad and the hired man did twice daily on their break from field work. As time marched on I did "grow up" to where I could assume my share of those daily tasks. My brothers, Dean and Dan, as they grew, also came into their own, chorewise.

I began first by observing and following Dad around the barn and farmyard as he carried water and feed and bedding straw to the horses, cows, and pigs and milked the cows and separated the milk and fed the small calves. It was all very interesting to me, and I was full of questions at each chore station, not realizing I was learning.

When I became old enough and was judged to be responsible enough for the job, I was charged with carrying the lantern at chore time in the dark season of the year, thereby freeing Dad's hands. Dean, two years younger than I, also came to be of use as lantern carrier and chore apprentice, thus making it possible for the hired man to also have one to carry a light for him.

The years sped by and soon Dean and I were taking our rightful place at chore time, assuming more of the "grownup" tasks, eliminating the need for a hired man. The chicken chores were the first ones we were entrusted with: feeding, watering, and gathering eggs. Then it was feeding the horses each a measure of oats and feeding the pigs one ear of corn at a time from a basket hauled from the corncrib on our little wagon.

In spite of the repetitious confinement of chore time, it gave us a sense of structure and security. We knew why, when, and where we were to be. We knew that there were those that depended on us for their comfort and sustenance—not only our livestock but our family members as well. Chores gave us a purpose for being.

I remember being puzzled one time when hearing some kids talking about their "allowance." I didn't know the meaning of the word. I never dreamed of getting paid for our work around the farm. As far as I was concerned, I was a part of the common effort in farming. My brothers and I were well provided for on a daily basis and on Saturday nights we were given a few coins to spend as we saw fit. This being during the Depression years, there weren't many coins available. We usually bought our favorite licorice sticks at a penny a piece.

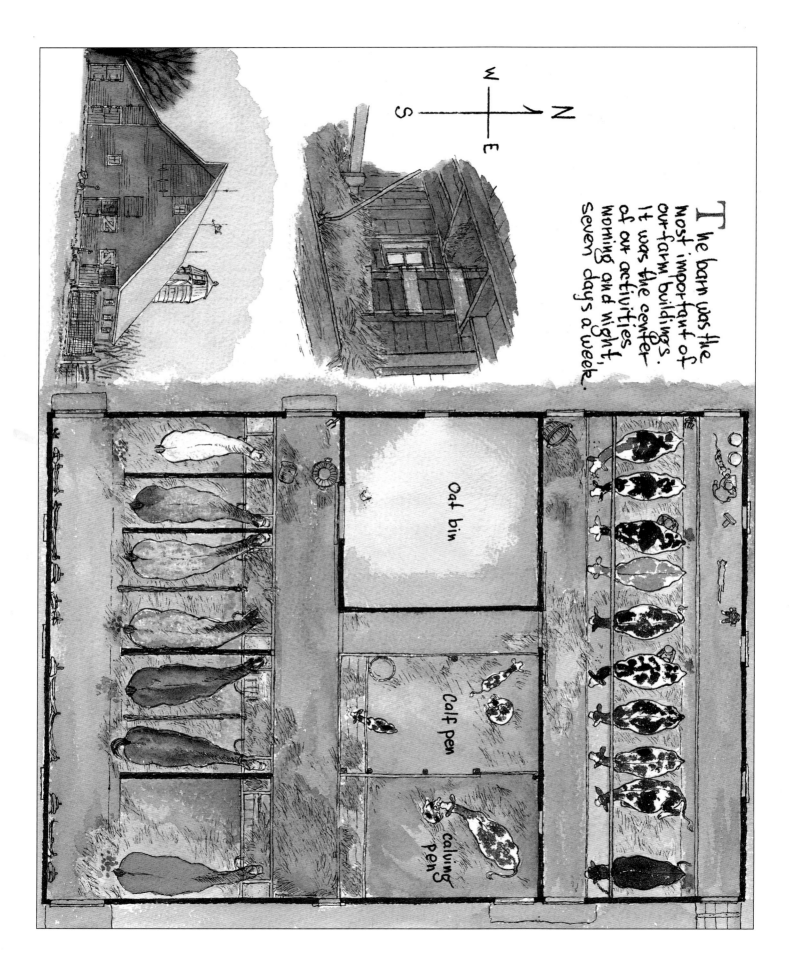

The barn was the most important of our farm buildings. It was the center of our activities morning and night, seven days a week.

N
W
S
E

Oat bin

Calf pen

Calving pen

BARN CHORES

When coming home from school, there was comfort in the chore routine. We ate the snack that Mom had for us in the kitchen, to "tide us over" until supper, changed into our chore clothes, and engaged ourselves in our familiar role.

If the day had been stressful, going to the barn and being with the animals was especially good. It could be therapeutic. In fact, entering the barn, with its unique medley of familiar smells, was like entering a different world, a world I felt very much at home in, among the creatures that I knew and felt a love for and in return, sensed a reciprocation of that feeling in their own way.

Our barn was not, like those of our uncles, large and impressive. In fact it was of modest style and proportions. It originated as a horse barn with stall space for twelve horses, and a large square oat bin, sixteen feet square, on the lower floor. A large loft over all was for loose hay and straw. Later, a lean-to was added along the north side as a cow barn, with stanchions for eleven milk cows. We usually milked less than that, so we had space in the last stanchion for the bull, secured by a halter and stout chain fastened to a wall timber.

Each milk cow had her chosen place, and when the door was opened to let the waiting herd in, she scrambled and shoved her way in to claim it, trying not to offend the self-appointed boss cow, who had her own priorities.

In front of the stanchions was the feed trough or manger, into which each animal was given a measure of silage topped with ground oats and linseed meal. In the winter, after the evening milking was done, the cows were kept in the barn overnight. There they could lie down in the straw bedding and, with their heads through the stanchions, feed on clover hay that had been forked into their manger.

One of the least desirable cow barn chores was cleaning the gutter. Since the cows were kept in overnight in the winter, the gutter had to be cleaned daily. While this was a distasteful job, there was satisfaction in making the place clean with fresh straw spread for the cow's comfort. Though it was by no means an easy task, the winter cow barn chore I liked most was carrying in a basket of silage for each cow. Then, having provided for the food and comfort for the cows, the barn was ready for the evening milking.

The horse barn chores included leading each one out to drink from the tank, giving each a measure of oats in its feed box, and forking hay into the manger. Throwing hay down from the loft was done before dark in order to avoid the danger of taking a kerosene lantern into that combustible place.

The silo was also a site of our winter chores. The long climb up the ladder and into the barrel of the structure, in order to throw a counted number of scoops full of silage down the chute for feed for the cattle, was another daily task.

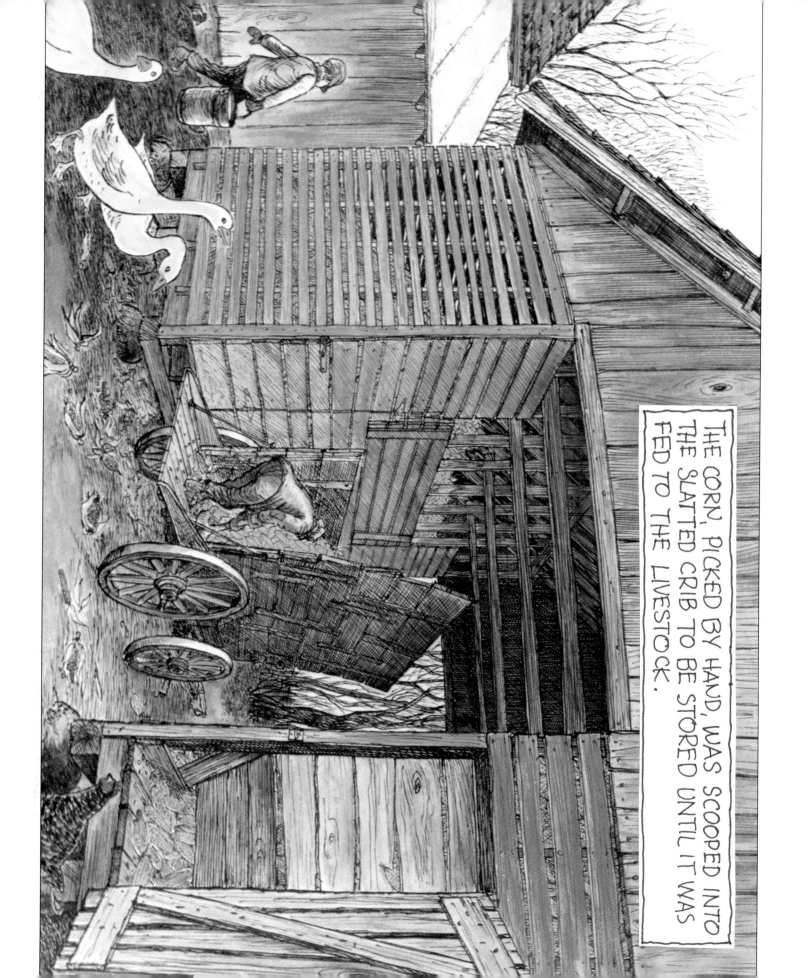

THE CORN, PICKED BY HAND, WAS SCOOPED INTO THE SLATTED CRIB TO BE STORED UNTIL IT WAS FED TO THE LIVESTOCK.

PICKING CORN

The corn harvest, when corn was picked and husked by hand, seemed to take up most of the fall. We sometimes started in late September and continued through October and November. The aim was to be through picking by Thanksgiving Day, but I can remember coming in with our morning's load at noon on that great feast day, taking time out for the Thanksgiving meal, and then returning to the field for another load before evening chore time.

Corn was considered such an important crop that many other autumn activities were expected to make allowances for it. In fact, during my first year or two in country school (mid-1920s) we were given a week's corn-picking vacation so that kids could help with the harvest. We liked getting out of school for a week, but it wasn't much of a vacation, if the weather was favorable.

Often there was a coating of frost on corn stalks and grasses when we first went to the field in early morning. By about mid forenoon, when the sun was well up in the sky, the frost would have melted, our mittens would be soaked, and we'd have to shed our jackets. As we rode in from the field at noon atop the jostling load of freshly picked corn, we enjoyed our brief rest and the prospects of dinner that Mom had waiting for us.

It was during the noon break that the corn was unloaded into the crib, one scoopful at a time. Then we reluctantly went back to the field, riding the empty wagon, with its "bang boards" high on one side like wooden sails on a ship. At the edge of the field the horses were turned into the previously picked rows and each of us took a standing row or two for which we were responsible. The corn stalks and leaves were crackly dry by now. Each of us wore a husking hook strapped to our right hand. With this hook the ear was stripped of its husk and tossed into the wagon. The first ear made a resounding thump as it landed in the empty wagon box, reminding us how far we were from seeing the golden ears beginning to appear above the top of the box.

Before hybrid seed corn had been put on the market, we selected our own seed for next season's planting by saving the best-looking ears from those we were harvesting. A wooden box was attached to the side of the wagon into which these ears were deposited as we worked our way through the field.

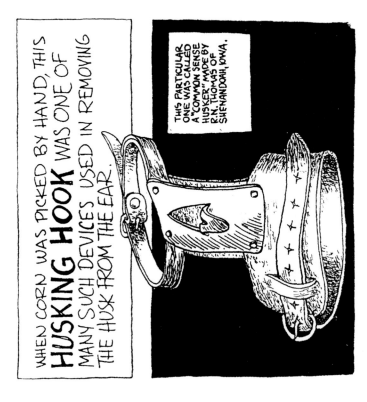

WHEN CORN WAS PICKED BY HAND, THIS **HUSKING HOOK** WAS ONE OF MANY SUCH DEVICES USED IN REMOVING THE HUSK FROM THE EAR.

THIS PARTICULAR ONE WAS CALLED A "COMMON SENSE HUSKER" MADE BY R.N. THOMAS OF SHENANDOAH, IOWA.

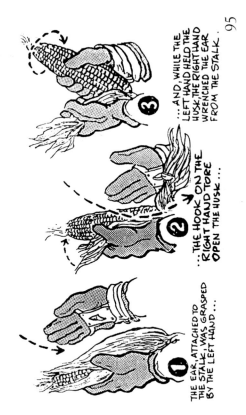

THE EAR, ATTACHED TO THE STALK, WAS GRASPED BY THE LEFT HAND...

...THE HOOK ON THE RIGHT HAND TORE OPEN THE HUSK...

...AND, WHILE THE LEFT HAND HELD THE HUSK, THE RIGHT HAND WRENCHED THE EAR FROM THE STALK.

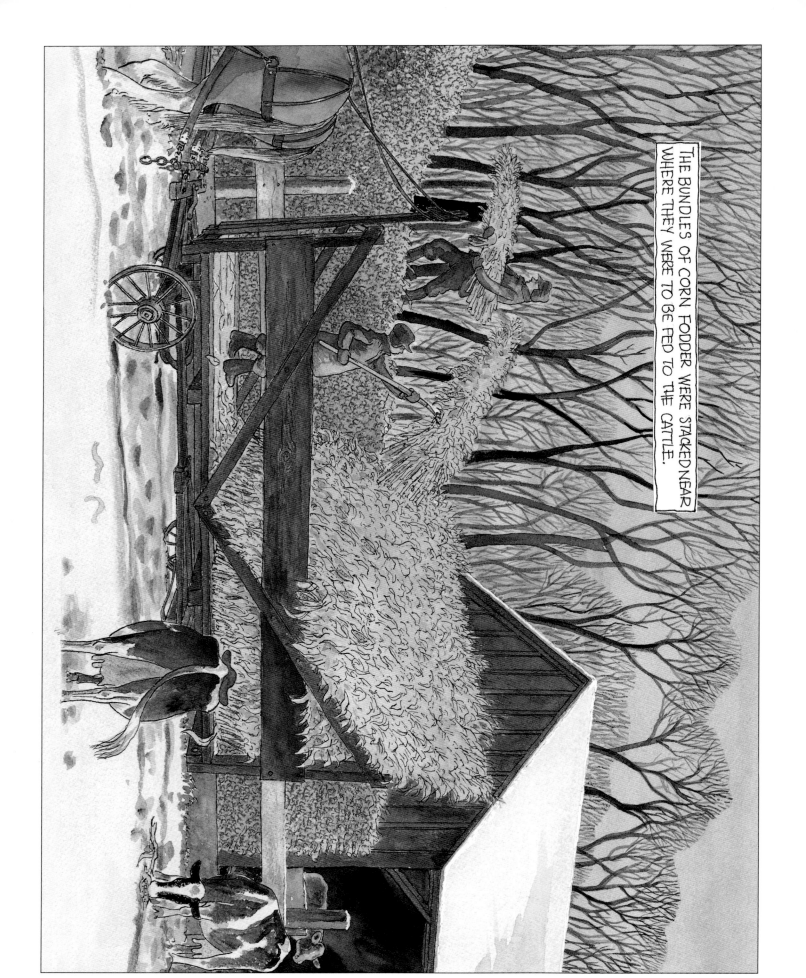

THE BUNDLES OF CORN FODDER WERE STACKED NEAR WHERE THEY WERE TO BE FED TO THE CATTLE.

STACKING CORNFODDER

There were several ways we harvested the corn crop. Early in the fall, when the corn ears were mature enough to make good feed, we sometimes put a temporary hog-tight fence through a portion of a standing field of corn. Feeder size hogs were turned into this fenced field, where they could break down the stalks and feed upon the ears. The practice accomplished two purposes. It meant less corn to pick by hand and, by not having to feed the pigs, less chore time.

Sometimes, if letting the pigs "hog down" the corn in the field was not practical, we had the extra chore of cutting a row or two of standing corn around the edges of a field. Besides collecting feed for the pigs, we were opening up the fields for the corn binder and for picking corn later on. This was done by hand, using a corn knife or machete, and, after loading these ear-bearing stalks onto a wagon, they were then hauled to the hog lot where the pigs fed upon them with gusto.

Silo-filling time in early September was when the corn was harvested as silage. It wasn't long after the silos of the neighborhood were filled that corn binders were again in the fields cutting corn fodder to be shocked. From those shocks, the fodder was

hauled to the farmyard to be stacked or shredded. All of these methods of harvest meant less corn had to be picked by hand.

Stacking corn fodder was another aspect of harvest that entailed long exhausting hours of bending and lifting, with short rests to and from the fields. But as with the other harvests, there were compensations. It was good to see the shocks gradually disappearing from the field and the stack steadily growing in the farmyard. The corn fodder stack was put near where it would be handy to feed in place of silage, should that not be available. The cattle liked the fodder with the ears in it, and they slicked up ears, husks, and leaves, leaving only the hard stalks. However, if given a choice, they seemed to prefer the moist silage to the dry fodder, even though both contained the whole corn plant.

Even though the corn fodder had essentially cured standing for two or three weeks in shocks in the field, after it had been put in the stack, it went through another "sweat" period, emitting a pleasant, ripe smell, unique to it. Its presence, along with that of the hay and straw stacks in the farmyard, gave an atmosphere of plenty and security.

YOU KNOW SOMETHIN'? WE'RE ABOUT THROUGH SHOCKING

YEAH — BUT LOOK AT ALL THERE IS LEFT TO PICK

THE MORE CORN THAT WAS CUT FOR FODDER MEANT THE LESS THERE WOULD BE TO **PICK** BY HAND — BUT THE MORE THERE WOULD BE TO **SHOCK** BY HAND.

SOMETIMES WE FED THE CATTLE CORN FODDER WHICH WAS ROUGH AND DRY LIKE HAY AND NOT AT ALL SUCCULENT LIKE SILAGE.

WE FED IT FROM A STACK....

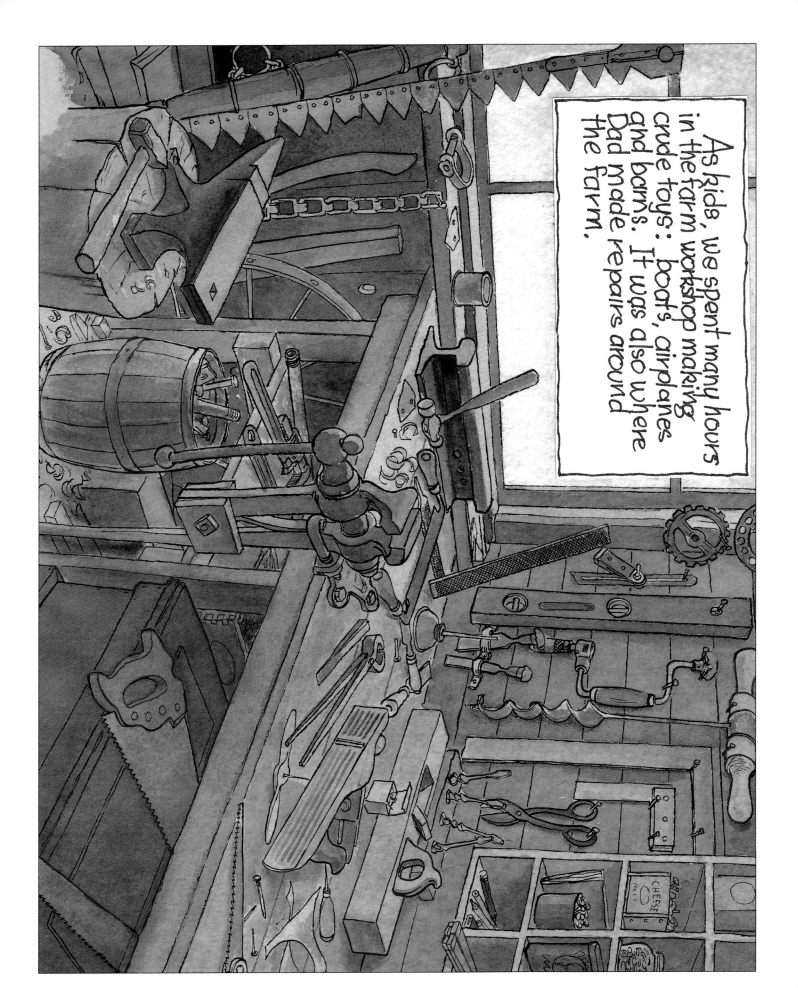

As kids, we spent many hours in the farm workshop making crude toys: boats, airplanes and barns. It was also where Dad made repairs around the farm.

WORKSHOP

After the new chicken house had been built, the lean-to on the east side of the granary that had housed our hens became our workshop. We cleaned out all evidence of its former inhabitants and hauled in and leveled a load of fresh dirt for the packed earth floor. It was with great excitement that we built the work bench and collected the few basic hand tools, most of them very old, from their scattered places in the garage, engine house, and granary, and installed them in our new shop.

We boys spent much of our free time in the shop, building toy airplanes with carved propellers that spun in the wind, planes that Dad showed us how to make. We built toy boats for the pasture creek. We made several of these using scraps of wood we found around the farm. Our most successful one was carved from a piece of spruce from one of our own trees. The wood was soft and light, and easy to work. Mom helped us make a sail for it. We named it the *Victoria*, and it saw many adventures, even pirates, as we towed it up and down the creek in that otherwise peaceful pastoral setting. Now the hull, in a dusty corner of a shed, is all that remains of that noble craft.

We also made small buildings for our play farms. Our lumber supply came from discarded orange crates we got from the grocery store and wooden boxes that window glass had been shipped in. The hardware store in Latimer gave these to us. They were made of cypress wood boards a quarter inch thick by about twelve inches wide and forty-eight inches long. When we carefully dismantled the boxes, we even recycled the nails!

Dad, of course, used the shop for the practical purposes of repairs around the farm. Our only power tool (arm power) was a wall-mounted drill press. Dad used it often in repairing farm equipment. He sometimes also would help us with our projects and make things for us. Over the years, when we were young, he

surprised us on Christmas with toys he had made with his few tools. One summer he made us a working model of a hay stacker, so we could make hay for our little "play farms." This hay, cured in the sun, together with the smell of cypress wood, produced a pleasant fragrance from the haymows of our miniature barns.

Beneath the workbench was a battered old tool chest that had belonged to Grandpa Amos Artley. It had in it some of the ancient tools he had used when he had built the first house on the farm, which became our granary.

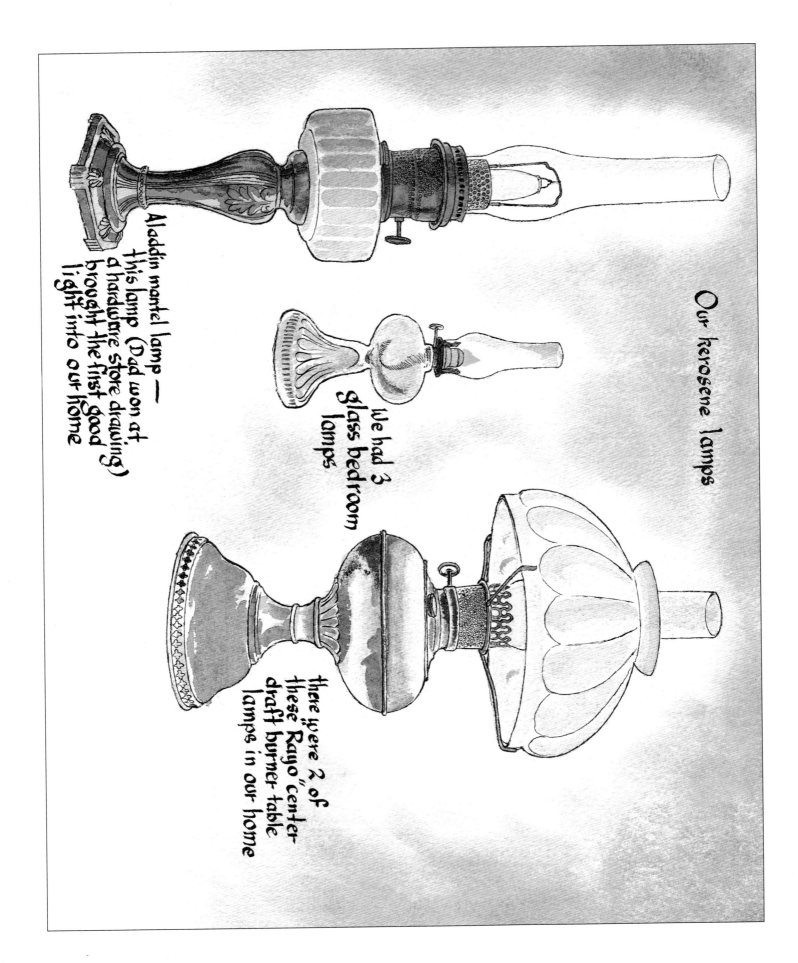

Our kerosene lamps

Aladdin mantel lamp —
this lamp (Dad won at
a hardware store drawing)
brought the first good
light into our home

We had 3
glass bedroom
lamps

there were 2 of
these Rayo "center
draft" burner table
lamps in our home

WINTER
KEROSENE LAMPS

One of the enduring images of our home was, and is, the light in the south window of the dining room that we see when coming down the hill toward the farm at night. Then it was a kerosene lamp. Now it is electric.

When we were finishing our chores on a cold winter night, ready to go in to supper, it was to the warm yellow glow of those kerosene lamps that welcomed us into the fragrant kitchen. After the supper things were put away, the lamp or lamps were carried into the dining room and set on the large round oak table. It was here that we did our homework or drew or played board games. On special evenings a large dishpan full of popcorn was placed in the middle of the table beside the lamp and we read while feeding on popcorn.

Sometimes one of the nickel-plated metal lamps, with the circular wick that put out more light than the single-wick glass lamps, was placed on top of the bookcase in the living room so we could read by its light while being near the warmth of the heating stove there. The glass lamps with their single flat wicks were carried upstairs when we went to bed. One small glass lamp was kept lit as a night light on the floor in the hallway.

The brightest and fanciest of our lamps was a kerosene mantel lamp that Dad surprised us all with, including himself, by winning the lucky number at a hardware store promotion. Its bright, white light, produced by its fragile mantel, made all our other lamps seem even dimmer than ever. However, to get the bright light the mantel lamp could provide it required special care. The wick had to be carefully cleaned each day so that a flame would not shoot up and blacken the mantel. And the mantel itself, made of a very fragile filament material, dare not be touched or even jarred or it would shatter.

In fact all of the lamps had to be serviced every day. The wicks had to be trimmed, the glass chimneys washed and polished, and

each lamp had to be filled with kerosene. The latter was one of the chores we boys were entrusted with.

When electricity finally came to the farm in the late 1930s, it truly was a time of enlightenment for us. To be able to simply flip a switch and have an instant bright light was one of the greatest marvels of the twentieth century for those of us who had groped our way through the half-light of kerosene lamps. But still, when there is a power failure, and we have to resort to the use of a kerosene lamp for a while, I feel nostalgia for those simpler, if darker times, that the dim yellow light and the slight odor of the burning kerosene evoke.

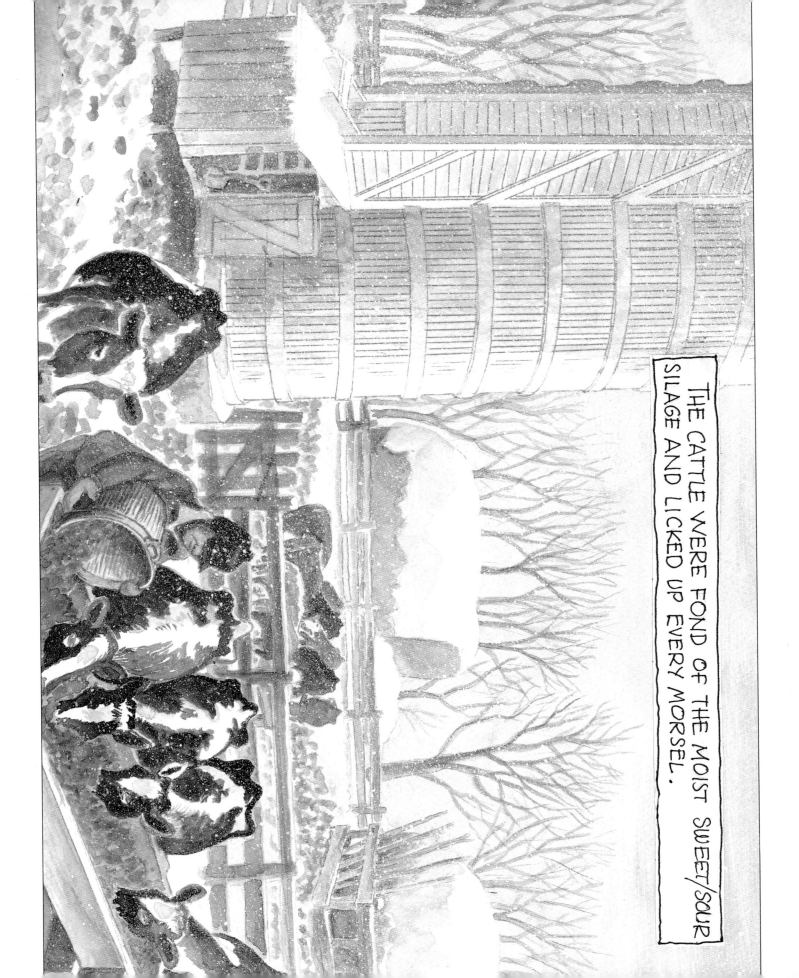

THE CATTLE WERE FOND OF THE MOIST SWEET/SOUR SILAGE AND LICKED UP EVERY MORSEL.

FEEDING SILAGE

Climbing the long ladder up into our silo, shoveling down a hundred or so scoops of silage, and then carrying basketfuls to the feed bunks among a herd of jostling cattle was not a chore for a child. So the job fell to Dad until we were into our teens and able to manage it on our own. At first I climbed the long ladder in the silo chute with Dad close behind me, with his arms on either side of me, grasping the rungs of the ladder. It was still scary, especially when we reached the opening near the top and I had to reach a leg over the threshold and pull myself in onto the silage. Inside the barrel of the silo, on top of that mass of silage, I felt reasonably secure, even though we were thirty or more feet from the ground. After the required number of scoops of silage had been thrown through the opening and down the chute to the pile in the silo house, it was scary to again have to climb out through the opening onto the ladder and down onto the pile of silage.

The access doors into the silo, at each level, were only about twelve inches apart, one above the other. As the column of silage was lowered every few days, the door had to be taken out and moved to the empty opening above it. This was done while bracing oneself on the ladder in the chute. I found this also to be a somewhat scary procedure. It was something we boys did not attempt until we were adept at going up and down the ladder, and sure of our footing and handholds.

As I have said elsewhere, silage was a moist, sweet/sour-smelling feed, made up of finely chopped, moist provender, in this case corn fodder, including the ear of corn. It was a feed the cattle were very fond of. In fact, I thought it smelled good enough to eat, myself, but trying a morsel of the good-smelling fare was disappointing. I decided it smelled much better than it tasted, and was content to leave it for the cattle to eat and for me to enjoy for its fragrance.

SILO

SILAGE

THE CHUTE

TRAP DOOR

THAT SERVED AS A VALVE TO DEFLECT THE SILAGE INTO THE WAGON

DAD DEVISED A SYSTEM OF TRAP DOORS AND CHUTES TO LOAD SILAGE INTO A WAGON

SILO HOUSE CHUTE

SILO HOUSE

IT SMELLED GOOD

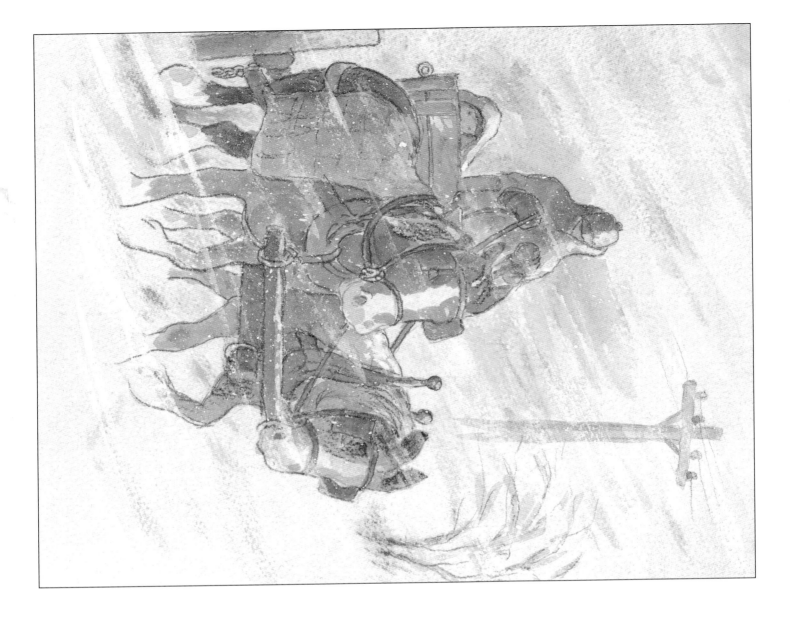

DRIVING MITTENS, SOMETIMES MADE OF HORSE OR COW HIDE, WERE ESSENTIAL FOR WINTER DRIVING.

THEY WERE LARGE ENOUGH TO ALLOW BULKY WOOL LINERS TO BE WORN INSIDE.

SCOTCH CAP

BLIZZARD

We were well acquainted with the storms that swept across the prairies, from the violent thunderstorms, hurricane-force winds, and even devastating tornadoes and, in the winter, the heavy snowfalls and ice storms.

But probably the most widespread life-threatening winter storm was a full-fledged blizzard. In such storms the air was frigid and the gale-force winds blew the finely powdered, suffocating snow into cracks and crevices and piled up drifts around buildings and across roads, making travel all but impossible. Anyone caught out in such a storm was in mortal danger, and there were accounts of those who became lost and died. Even wild creatures of the fields were sometimes victims of a blizzard. Particular precaution was taken with the farm animals to make sure they had adequate shelter.

Often a deceptively mild day could suddenly turn ugly, catching us all unawares. One such day we went off to school oblivious to what was about to occur. By about mid-morning the wind suddenly picked up and shifted to the northwest. Fine powdery snow soon filled the air and the temperature plummeted. A window left slightly open for fresh air in a formerly mild morning was now closed, and a couple of us older boys were sent to the coal shed to get more fuel.

By noon a full-scale blizzard was raging around our little one-room country school, isolating us from the surrounding community. Our schoolhouse was without electricity or even a telephone. We all, including the teacher, were filled with growing concern.

Presently a snow-covered figure in the person of a neighbor from across the road brought word of imminent rescue. Her telephone on the party line had been abuzz with messages from parents as to plans for picking up their children. A complex rescue system had been worked out for all of us. Those going east were to be picked up by team and bobsled and taken to their homes. Dean and Kenneth and I were to go with the neighbor from across the road and wait at her house for Dad and Kenneth's father to pick us up in a horse-drawn wagon.

Within the next hour, everyone going eastward had been gathered up and was on their way. Dean and Kenneth and I were finally relieved to see the shadowy form of our rescuers emerging out of the storm to take us home. With extra sweaters and blankets, hot coffee, and donuts provided by our good-Samaritan neighbor, we were soon headed for home in the full fury of the storm.

As we gathered around our lamp-lighted supper table that night with Dad, Mom, Dean, and little brother Dan, I was keenly aware of my riches and could wholeheartedly enter into the spirit of Dad's table prayer of thanks.

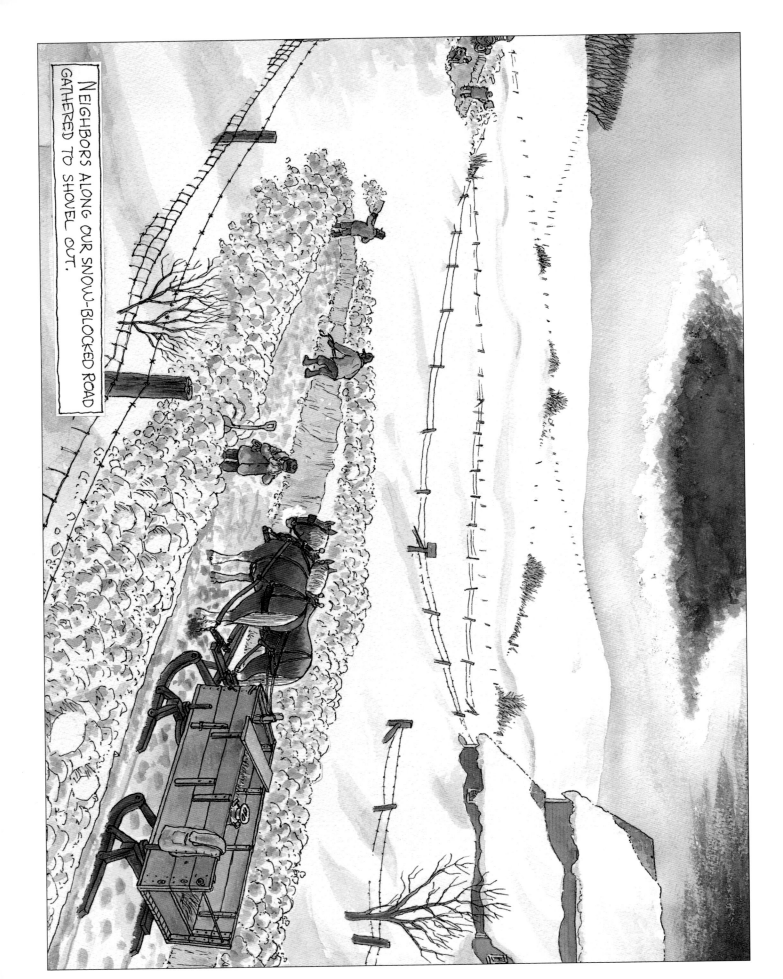

NEIGHBORS ALONG OUR SNOW-BLOCKED ROAD GATHERED TO SHOVEL OUT.

DIGGING OUT

Some of our winter storms were of such proportions that the countryside was virtually immobilized. Only the state highways had snow-removal equipment in the form of snowplows mounted on the front of large, hard-rubber-tired trucks left over from World War 1. And when these were not adequate to go through some of the huge drifts, road crews with shovels had to dig by hand.

The railroads used enormous plows mounted on the front of a flat car that was pushed by a steam engine. Even with all that steam power, clearing the tracks for travel was a slow process requiring backing up and pushing again and again in some of the larger drifts. Great interest was engendered in the community when a large rotary snow plow, forerunner to the snow blowers used by many homeowners today, was first used to clear huge snow drifts from some of the cuts the railroad passed through.

However, for those of us who lived on the county and township roads, when it came to making them passable again, we were on our own.

The nature of farm work was that each farm was more or less an entity unto itself, depending on its own resources to get things done. However, when it came to the big jobs like haymaking (sometimes), threshing, silo filling, corn shredding, and digging out after a blizzard, neighbors came together in a joint effort.

After a crippling winter storm, the telephone on our party line would be jingling as neighbors living along our road conferred and made arrangements to meet to shovel out. Each farmer, bundled in his winter work clothes, brought his ubiquitous scoop shovel and went to work. This assembled crew, usually in half a day, amid much good-natured banter, cleared a roadway enough so that a car or team and bobsled could once again reach the outer world. And each went home to supper that night with sore muscles but a heightened sense of the interdependence of neighbors.

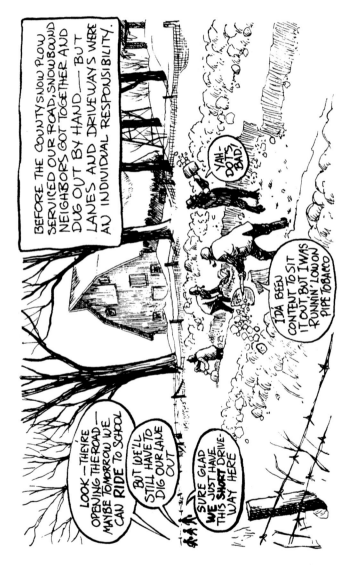

107

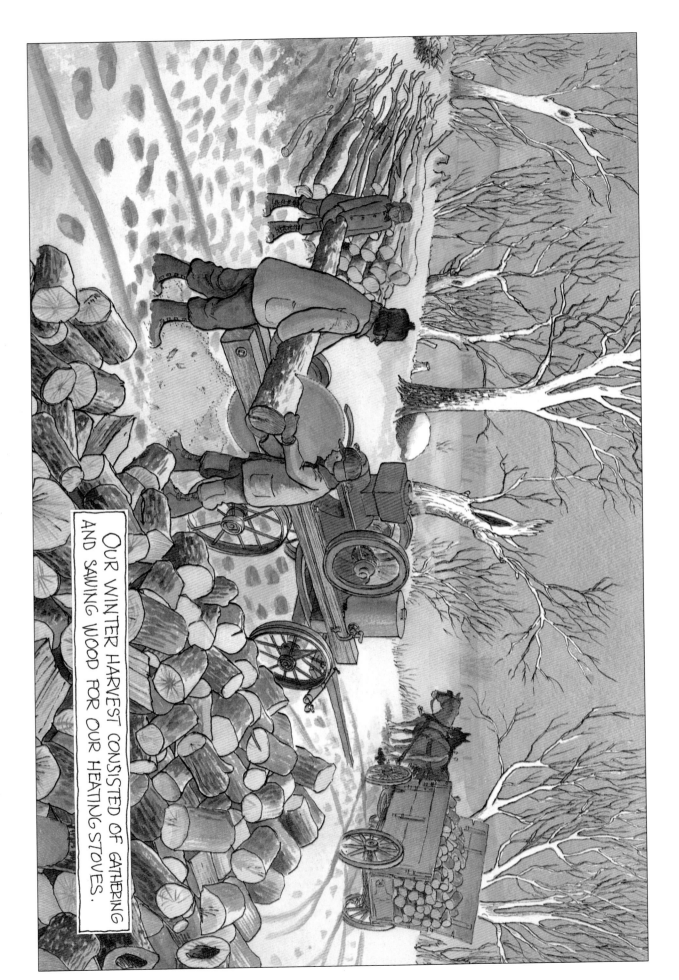

OUR WINTER HARVEST CONSISTED OF GATHERING AND SAWING WOOD FOR OUR HEATING STOVES.

SAWING WOOD

Our harvest season was not confined to summer and fall, when we brought in the bounty from the fields. Winter was also a time of harvest, when we gathered wood for fuel.

With the exception of the grove at the farmstead that Grandpa Amos had planted when he founded the farm, we did not have a timber or a wood lot. But there were a great many volunteer trees that had grown up in and around the pasture and along fencerows. There were some, mostly cottonwoods, that I think must have been planted by Grandpa about the time he planted the grove. These grew on the border between the slough pasture and the higher, tillable land. Two of these cottonwoods, enormous beautiful specimens, with deeply furrowed bark, were five to six feet in diameter at the base. They commanded the landscape all over the farm and beyond. I liked to stand at the base of these magnificent giants and look up into their airy branches with waxy leaves that rattled in the breeze. The cottony seeds of these trees spawned volunteers that grew up among those of ash, box elder, chokecherry, and soft maple.

Most of our winter harvest was gleaned from broken branches of these storm-felled trees, making it unnecessary to cut down a live tree. There was plenty to pick up.

Live storm-damaged trees were cut up into manageable logs, split into lengthwise pieces if too large to handle whole, and put in a pile to dry. Then the following winter these logs were cut into stove wood lengths and hauled to where they would be stored

near the house for easy access to the stoves. In the late twenties, when we got our first furnace, wood was stored in the cellar.

The fallen trees and limbs were cut up into pieces we could handle with the two-man crosscut saw, with Dad on one end and one of us boys on the other. It was a grueling job, requiring the saw to be pulled (not pushed) back and forth until the log was cut through. How much easier and faster a job that is with the powered chain saw of today!

Even though we were well bundled against the cold, and the strenuous exercise kept our blood circulating, our fingers and toes required much swinging and stomping to keep them from suffering frostbite.

These woodcutting and gathering jobs were not all bad, however. We took frequent breaks from our work to enjoy the lunches Mom had packed for us of ham sandwiches in home baked buns, cookies, and a Thermos of hot chocolate. We also could observe the winter wildlife around us: chickadees, crows, an occasional jackrabbit, and the sluggish wood ants that were spilled out of their hibernation from a cut log.

Sawing the logs into stove-length chunks was done with our circular buzz saw, powered by a one-cylinder gasoline Galloway engine mounted on a wagon chassis. Driving in from our day's work with our load of wood produced a feeling of satisfaction, much like that when bringing in our other harvests.

SCHOOL CHRISTMAS

After the Thanksgiving holiday, the school routine took on an exciting aspect. With the weather usually being inclement at that time of year, our recesses were often spent inside, sometimes being given to decorating the schoolroom with paper garlands, paper bells, and window decorations we all had a hand in making.

During the days we could not play outside, we were put to making simple gifts for our parents, siblings, and other relatives who would be attending our annual Christmas program. This was our big production of the year. Most of our recess times and much of our school time was devoted to preparation. Skits were selected so that each student would have a part. Recitations were memorized and carols were practiced over and over. Teacher was producer, arranger, director, and stage manager. When our pre-holiday excitement got out of hand, she was also arbitrator and disciplinarian.

On the night of the last day of school before Christmas vacation, our little schoolhouse, sitting alone on the frozen landscape, experienced a miraculous transformation. Its windows were aglow with light from kerosene lamps and hissing gas lanterns. A gingham curtain, strung on a wire across the front of the room, made a stage of the raised teacher's platform. The room, packed with parents, siblings, grandparents, aunts and uncles, and friends and neighbors in winter dress, became quite warm in spite of the cold winter night, making the fire in the stove hardly needed.

After the program of skits, recitations, and carols came to a close, the audience applauded, the teacher thanked everyone for coming, and the women opened boxes and baskets they had brought and distributed sandwiches, cakes, cookies, coffee, and hot chocolate to the festive gathering.

When the debris of the party had been put away, the lights extinguished, the stove made secure, winter wraps put back on, and the door was locked, people left for their homes. The cars, bobsleds, and sleighs took off in all directions, leaving the little schoolhouse alone in the winter landscape, which it would be for the next two weeks.

FAMILY CHRISTMAS

Usually on Christmas Eve the chores were done up early. We would get cleaned up and into our best clothes, bundle up in our winter wraps, gather the boxes and baskets containing presents and food for the potluck supper, and drive into town to Grandma Artley's house. There she greeted each of us at the door and welcomed us into the warmth of her house full of aunts, uncles, and cousins, creating a happy confusion.

After the tasty supper, we went to the church for the annual Christmas Eve service. This was put on by the Sunday school and consisted of recitations, carols, and a tableau retelling the story of Jesus's birth. When the religious part of the service had been presented and the pastor had given the benediction, Santa Claus appeared and handed out little sacks of treats to all present.

When we got back to Grandma's, we warmed ourselves in front of a log fire on the hearth and contemplated the beauty of the decorated tree and its bounteous pile of gifts beneath. After the gifts had been opened, the debris was picked up. Each family gathered their own presents, empty casseroles, and cake pans, and prepared for the cold trip to their homes. Grandma saw each family member to the door with a "goodbye" kiss and a "Merry Christmas" hug.

Back home the banked fire in our living room stove was stirred into life and the kerosene lamp was lit. The light from the lamp was reflected into a multitude of sparkling reflections from the tinsel decorations of an otherwise dark tree. Then, after hanging stockings on the backs of chairs, since we had no fireplace mantel, we went off to bed to try to sleep while images of the Christmas excitement flooded our minds.

Christmas morning, with its fragrance of hot cocoa and fresh-baked buns and bacon wafting through the house, found us kids dumping out our stockings to see what Santa had brought. After a hurried breakfast, we all gathered in front of the tinseled, pine-scented tree to tear open the packages that had mysteriously appeared during the night. Quite often the best presents of all were those that Dad had made for us in his workshop.

About mid-morning on Christmas day we repeated the scenario of the night before, this time traveling a few miles to Grandma and Grandpa Crow's farm for the gathering of relatives on Mom's side. This, too, was a happy, noisy occasion, with lots of delicious food and the warmth and excitement of the gift exchange.

Of all the Christmas celebrations, as good as they were, some of my most cherished memories of the season were those Christmas eves we spent at home. (Usually this break with the traditional pattern was due to sickness of someone in the family.) On those special times, the chores having all been done, the farm animals watered, fed, and bedded snug in their pens and stalls, we were in for the night to gather around the warmth of a happy home. Even though this was during the Great Depression, our Christmases were memorable. I would guess that there was no cathedral, palace, or mansion that could have contained more of the spirit, joy, and love of Christmas than was experienced in our humble farmhouse—a spirit to be carried on by us boys in our own families in years to come.

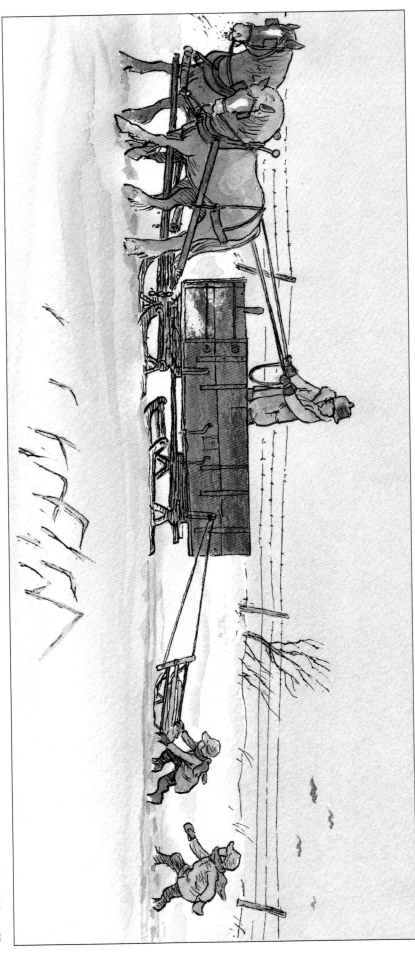

WINTER FUN

As a boy on the farm in the 1920s and 1930s, I looked forward to the first snowfall with as much glee as my peers. When a leaden sky on a cold early winter day began to sprinkle down, first a few and then a shower of those first snowflakes of the season, we were ecstatic. We would catch and examine the intricately designed flakes on our mittens, or try to catch them on our tongues, enjoying the refreshing bit of cloud.

Long before enough snow had accumulated to support them, we brought our coaster sleds out of the shed and tried unsuccessfully to slide with them on the fluffy white coating on the ground. When the snow had built up and packed down sufficiently to make for good sledding, we soon had the hill behind the cattle shed shiny and slick with much use. We found out that even a scoop shovel made a fairly good, but cramped, downhill slide. One frosty moonlight night, Mom, Dad, and we three boys, as well as our dog and pet sheep, riding on a homemade pony sled, made several gleeful trips down that hill.

We also enjoyed riding in the bobsled behind the horses. We took every opportunity we could get to ride along when Dad took the bobsled to Latimer to pick up supplies. It was fun to be sliding smoothly along in the sled with the horses at an easy trot. Their muffled steps in the snow, the clinking of their harness, and the low rumble of the sled's runners were all that broke the silence of those memorable trips.

Sometimes we were permitted to hitch our coaster sled for a free ride. Occasionally the deep ruts in the snow would cause the sled to dump us, which added variety and fun. Of course winter cold did cause frosted toes and fingers on these trips. We often had to pay for this by suffering with chilblains, but it was worth it.

We also made snow sculptures, snowballs, and snow forts. We were engaged in some great battles, especially in our schoolyard, where we could muster more combatants. We would build two sets of snow forts and stockpile ammunition for battles that sometimes disintegrated into fist fights (hand-to-hand combat) . . . all part of our winter fun.

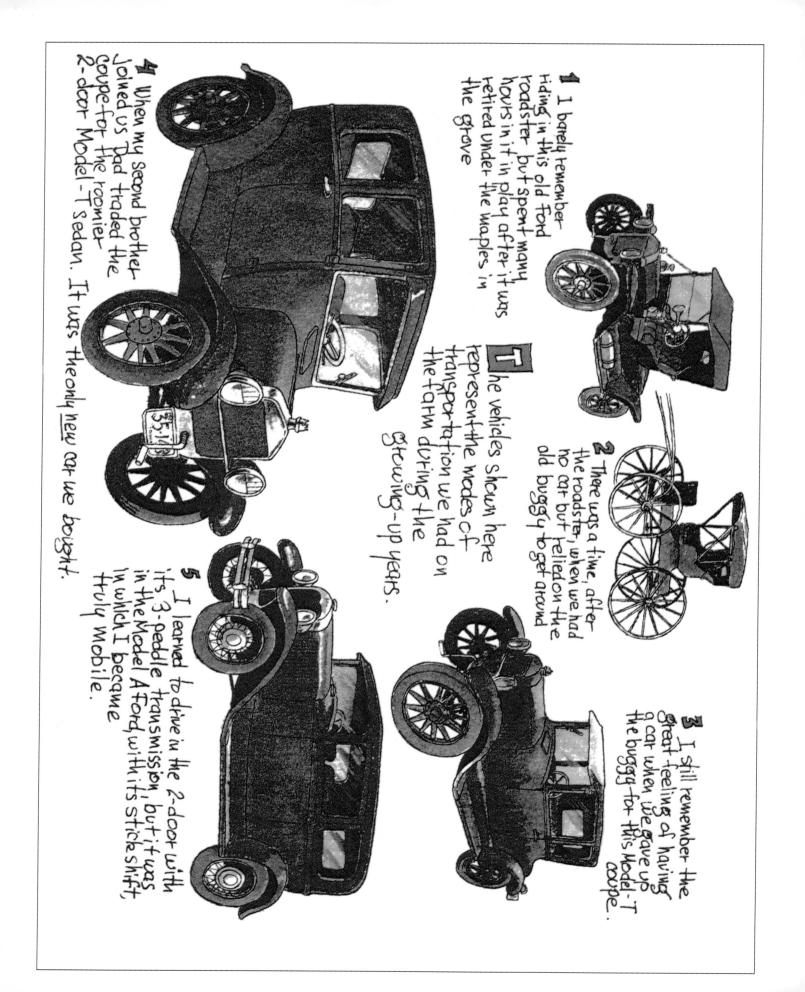

1 1 barely remember hiding in this old Ford roadster but spent many hours in it in play after it was retired under the maples in the grove

The vehicles shown here represent the modes of transportation we had on the farm during the growing-up years.

2 There was a time, after the roadster, when we had no car but relied on the old buggy to get around

3 I still remember the great feeling of having a car when we gave up the buggy for this Model-T coupe.

4 When my second brother joined us Dad traded the Coupe for the roomier 2-door Model-T Sedan. It was the only *new* car we bought.

5 I learned to drive in the 2-door with it's 3-peddle transmission, but it was in the Model A Ford, with its stick shift, in which I became truly mobile.

OUR VEHICLES

One of my earliest memories, although a very dim one, was riding into the alleyway in the corncrib, in the open Ford runabout. It seemed there was something wrong with the car. And indeed, it was never driven again but was pushed out into the grove where we kids enjoyed "driving" it. One day we came home from school to find some man had come to the farm and bought it. I have no idea how much he paid Dad for the old junked car, but if we had it today it would probably be worth a new modern car.

For the next few years we were without a car. I can still, in my mind, hear the grating of pebbles against the iron tires of the buggy as Dolly and Daisy pulled us along the mud road on our way to town on a rainy day. It was by horse and buggy, or wagon, or in the winter by bobsled, that we got about, getting groceries, coal for the stoves, or ground feed for the animals.

Sometimes Grandma Artley would come from town in her Willis Night to take Mom and my brother Dean and me shopping, or Aunt Bertha would come in Grandpa Crow's Overland touring car, to take us to Grandpa and Grandma's farm for overnight. And I remember how sorry I felt for Dad, as he saw us off, that he had to stay and do the chores while we were gone.

It was a great day when Dad's brother, Uncle Wayne, delivered the Model T coupe Dad had bought. It was a used car but it was new to us, providing us with the luxury of mobility without having to depend on others and the horses.

About four years later, as Dean and I grew, the coupe got to be pretty crowded for our family of four. Then one Saturday night we all went to town for the last time in the Model T coupe. We went to Wood's Garage, where Dad traded the coupe in on a new car—the only new car we ever had. It was a two-door Model T Ford sedan. As we transferred our things into the new car, I could not help feeling a little sad about leaving the coupe behind. But as we drove home that night in 1927, in our brand new car, with its new-car smell, what happiness we experienced, knowing that now we weren't cramped in with groceries and egg crates! Furthermore, we would have room for our new sibling (who turned out to be brother Dan) expected later that year.

It was in this Model T Ford that Dean and I learned to drive—no easy task, with the car's three-pedal transmission. There were some anxious moments in trying to stop when we'd push too far on the clutch pedal and engage the low gear. But we did learn to drive, without school-sponsored driver's training, a learner's permit, or a driver's license. None of these civilized prerequisites were as yet required for the emergence into the free-for-all of the highways.

Later Dad bought a used Model A Ford sedan for Dean and me to drive to high school, and later to college. This stick-shift transmission was much more user-friendly. It was in this car that we drove our first dates.

THERE WAS A COZINESS IN THE BARN WHEN WE AND THE COWS, AND EVEN THE CATS, CAME TOGETHER AT MILKING TIME.

MILKING TIME—WINTER

The cow barn at milking time in the winter was entirely different than it was in the summer. It was a cozy place where we and cows came together in the full meaning of husbandry. Before the cows were let into the barn, the gutter had been cleaned, fresh straw bedding had been spread for the cows to lie down in and spend the night, and portions of silage plus some ground meal had been put in the manger for each cow. As the door was opened, the eager bovines scrambled up the snowy ramp into the barn, with each seeking out her own place, thrusting her head through the stanchion.

For those not familiar with the ambiance of a cow barn at milking time, it is perhaps hard to appreciate the symphony of smells emanating from the place. There was the sharp sweet/sour fragrance of the silage, the enduring odor of cured hay from the loft, and that of the fresh straw bedding, the warm smell of the cows, and as we milked, the warm sweet smell of the milk as it foamed up in the pails.

Milking was the last of the evening chores, so it was pleasant to come into the comparative warmth of the cow barn with the soft, yellow glow of the kerosene lantern hanging from its wire hook. We each selected our own stool from the rack along the wall, stuffed

our mittens into our jacket pockets, and sat down next to a cow. It was pleasant to first slip our cold hands up between the warm, fur-lined place between the cow's udder and her flank.

The sounds were quiet ones made by the creaking wooden stanchions as the cows leaned into them reaching for their feed, the pinging of the milk stream into the empty pail, and then the "shush-shush" as the pail filled up with the warm foamy milk. There was the mewing of the cats asking for a bit of warm milk in their cat dish. In fact, the quietness of the place and the repetitive, automatic task of milking left our minds free to think of other things, and it was conducive to conversation.

Dad was quite well read and knowledgeable on a wide range of topics. It was during our milking sessions that we asked and were given answers to the mysteries of sex and reproduction. These cow barn conversations on the hows, wheres, and whys of this mysterious process, prompted along by growing boys' hormonal changes, were augmented by our observations of the farm creatures.

Sometimes singing alleviated the tedium of the process of milking by hand. We tried to sing songs that were lively and in time with the tempo of milking. "Springtime in the Rockies" and "The Old Gray Mare" were some of them.

Often our milking herd, during the winter, was down to as few as one or two cows. Dad was usually the sole milker then. And the separator, moved to the cellar for the winter, wasn't even used. Instead, the milk was taken to the kitchen, strained, and placed in covered crocks on the cellarway shelves. The next day, after the cream had risen to the surface, it was skimmed off. That not used at the table was put into a small glass butter churn and made into butter for our own use.

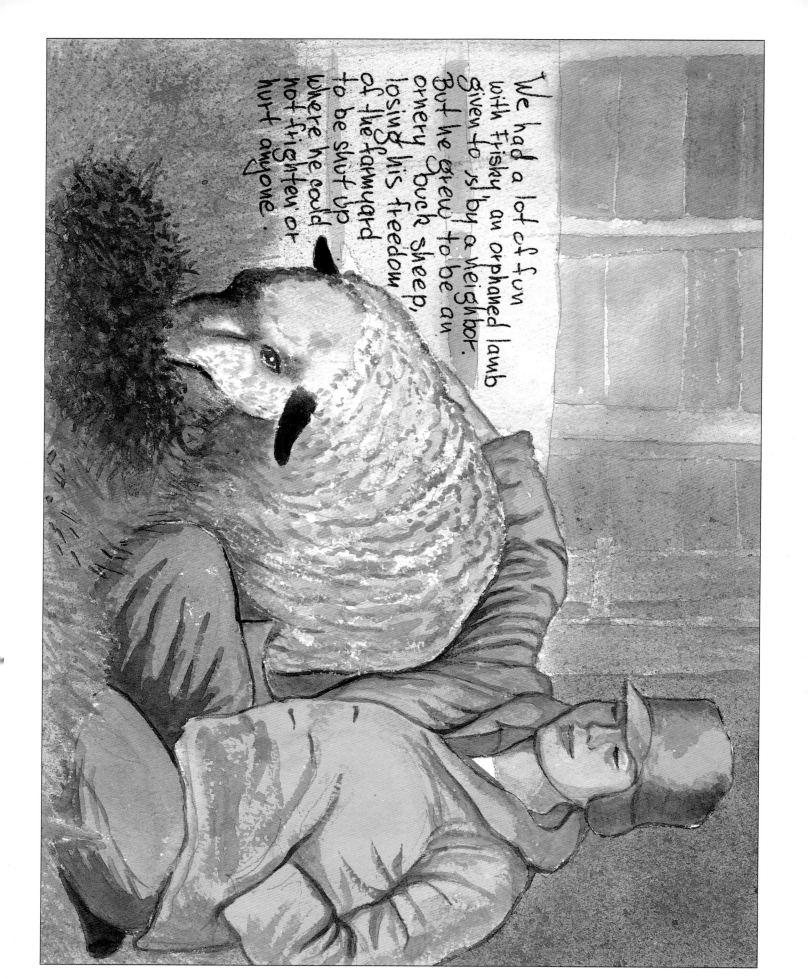

We had a lot of fun
with Frisky, an orphaned lamb
given to us by a neighbor.
But he grew to be an
ornery buck sheep,
losing his freedom
of the farmyard
to be shut up
where he could
not frighten or
hurt anyone.

PETS

We did not raise sheep on our farm; however, Dad did buy some lambs to pasture and feed for market, a couple of years. But this wasn't much to his liking. He much preferred cattle.

Thanks to a neighbor, we kids were given an orphaned lamb one spring. We named him Frisky, and that he was. We kept the lively little fellow in a large cardboard box behind the kitchen range. When he began jumping out of his box and clattering around the kitchen, Mom banished him to the barn. When the weather was nice we would take him out and romp around the yard with him. We laughed at the way he would try to jump over his own shadow and jump into the air for no reason at all but for the pure pleasure of it. He made an enjoyable pet.

However, he grew from the cute little woolly lamb to a big, hardheaded buck and began to push his way around. Visitors were frightened by his aggressive behavior, and when he began to use his head as a weapon, he was penned up and eventually ended up at a distant farm with a harem of ewes. Sadly, his end came when a dog killed him.

We had other pets while we were growing up. Of course, there were the family dogs, beginning with Scamp, a collie that my parents got for me when I was a tad and he was a pup. As we grew we were constant companions. He lost his right hind leg in an accident jumping over a wire fence one night. He got to be very mobile with his handicap and spent many happy years on the farm.

While Scamp was still living, a friend gave us a female Airedale puppy. Frazzels grew into a loveable member of the family and Scamp and Frazzels were close companions until Scamp's death. But Frazzels was too loveable, especially to the wandering male dogs of the neighborhood, and she had many pups, which were a delight when small but a problem when grown. Many were given away but one, Pat, grew to adulthood and became a good companion to his aging mother, until she didn't return from one of their many hunting trips. Pat died not long thereafter.

Tamey Turk, our pet turkey hen, came when we called her and followed us around the farm. We were saddened when she died, and marked her grave behind the corncrib with a granite slab with her name painted on it.

Dad gave us an orphan piglet one spring and told us if we cared for it and raised it, we could sell it and have whatever money it brought. We were continually wishing for a bicycle, so we determined that this pig would be our means to getting one. We named him "Bicycle," and in giving him special attention and care, before we realized it, he became a pet. When he grew to market size, with our dream of a bicycle fixed in our minds, we sadly sent him to market. But sadder still, the market was at its Depression low, and at three cents a pound we could not come close to turning "Bicycle" into a bicycle.

Our upstairs bed
rooms were without
heat in winter—
To help us keep warm
we sometimes used...

... a heated
soapstone...

... or a hot water
bottle.

The solid walnut bedstead
belonged to my mother's
parents when they had their
own home

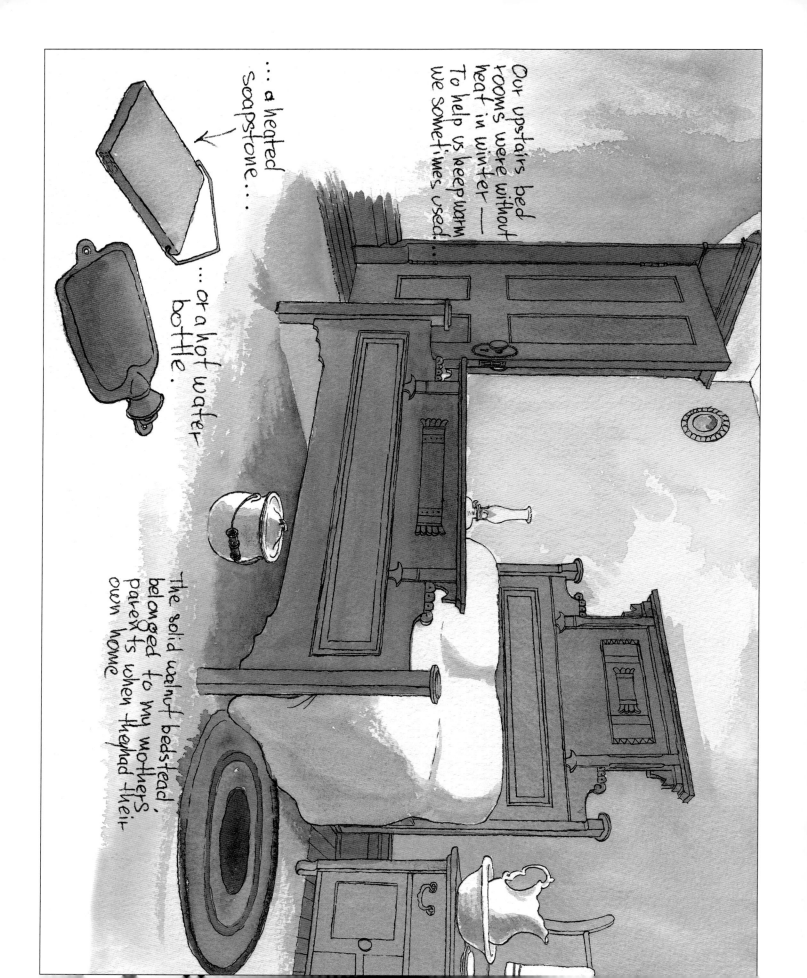

BEDTIME

Our upstairs bedrooms, being that our kitchen range and the living room stove produced the only heat in the house, were about as cold inside as outside in the dead of winter. So going to bed with any degree of comfort in subzero weather took some ingenuity.

We donned our warmest cotton flannel pajamas and wool socks. If the rooms were extremely frigid we sometimes wore stocking caps. Usually we each carried a hot water bottle to wrap ourselves around. There was also the soapstone, preheated in the oven, to put at our feet. This, however, we had to do with care in order not to burn ourselves. Usually it was slipped into a flannel cover to lessen the danger of burns. On particularly cold nights we took our underwear to bed with us so that it would be warm when we dressed in the morning. With the help of the soapstone, hot water bottle, warm nightclothes, cotton flannel sheets, and plenty of wool blankets and thick comforters, we boys were soon quite snug and cozy in our otherwise frigid bedroom.

When Dad or Mom would come in, before they retired, to check on us, ask if we had said our prayers, and blow out the light, we felt reasonably secure in the knowledge that we would

survive the night and awaken with the dawn to see Jack Frost's artwork on the window panes. With the sound of the snapping and popping of the house timbers in the cold and the wind rattling the windows, we soon drifted off to sleep.

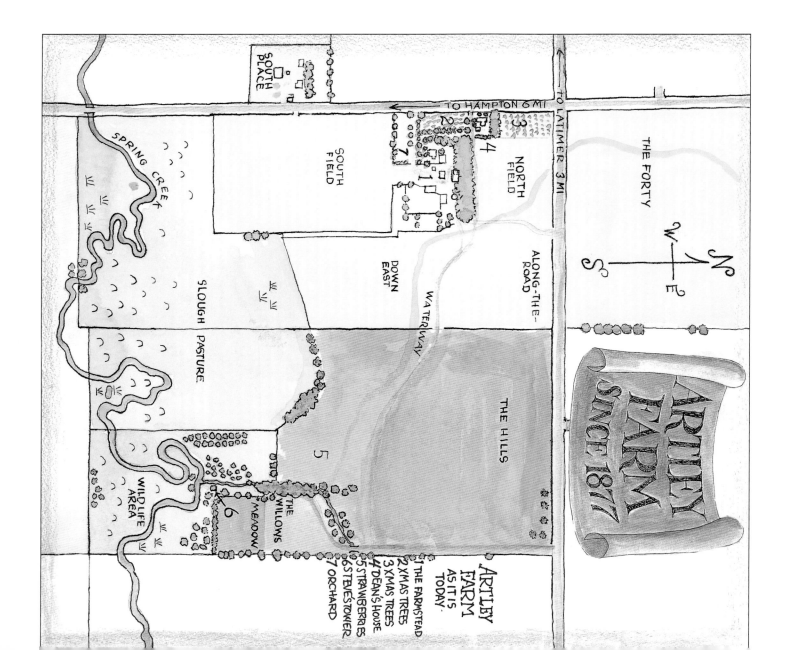

EPILOGUE

A PLACE TO COME HOME TO

I place my hand on the rough bark of the large old Norway spruce that stands on the eastern edge of the house yard. I feel affection for this ancient tree, planted 120 years ago by Grandpa Amos Artley. This venerable, lone survivor of several spruce that once shaded the yard, now is accompanied by a pin oak, three spreading locusts, and a young blue spruce, planted by my children, as a memorial for their mother, Ginny.

In the early June sunshine, the morning is bright and new. The lawn, freshly mowed the day before, is still wet with dew, and the scent of cut grass is heavy on the air. The fragrant purple lilac blooms are now past their season, as are those of the duchess apple tree near the back door and those from the orchard across the driveway. Also past blooming for the year are the five flowering crab apple trees along the north side of the lane to the road, given to my second wife, Margaret, and me as a wedding present from her five children.

The excited chatter of a little house wren, concerned by my presence, is part of a chorus of early morning bird songs. There is the soft twitter of the barn swallows perched on a high wire strung across the farmyard, from where they swoop and skim over the ground, gathering insects. They dart in and out of the open barn door to their mud nests plastered against beams and rafters.

All of these sights, sounds, and fragrances create an atmosphere that speaks of the timelessness of the farm. It is comforting to know that some things remain the same in spite of changes that have taken place here.

In 1927, when we got our first battery-operated radio, Mom made the sage remark, "Now the world has come into our lives and nothing will ever be the same." The radio, magazines, and daily paper, made us more keenly aware of the Great Depression we were encountering, and brought us disturbing news of the emergence of Hitler, Mussolini, and Japan's militarism, along with the despotism and unimaginable suffering they were causing.

All of this, of course, led to World War II and our nation's part in it. Our farm was touched by this development. Dean, a pilot in the Air Force, and I, in the medical corps, were involved for many years (ages, it seemed), and Dan, too young to serve in the war, later joined the Iowa National Guard, where he served until retirement. It was while serving in the army as laboratory technicians that Ginny and I met and married. Our two oldest children were born and lived their first few years on the farm.

Coming home after four years of the war, we were made acutely aware of the material changes that had taken place on the farm. Ginny and I contributed to that change in 1946 by building a house just beyond the grove. Later, after we left the farm, Dean bought it for his family's home.

No longer were oat and corn shocks familiar sights in the fields, nor did neighbors come together for threshing oats or shredding corn. Instead, large combines moved across the fields cutting and threshing the standing oats, with wagons transporting the harvest from combine to bins. Mechanical corn pickers, trailing wagons behind them, made harvesting ear corn a faster and easier job. A few years later, self-propelled combines moved across the fields of standing corn as well, delivering their golden harvest of shelled corn into huge wagons, which carry it to storage. Pick-up field balers make short work of haying and gathering up straw into bales from behind the oat combines.

Probably the most far-reaching change was when electricity came to the farm, bringing light and power. All of this mechanization changed the ambience of the countryside. The easy-paced movement of horses across the fields was replaced by the frenetic dash of tractors and, with the ease and speed this accomplished, made it easier to farm more land, leading to bigger and fewer farms. As a result, countless farmsteads are now gone, as well as the people who inhabited them.

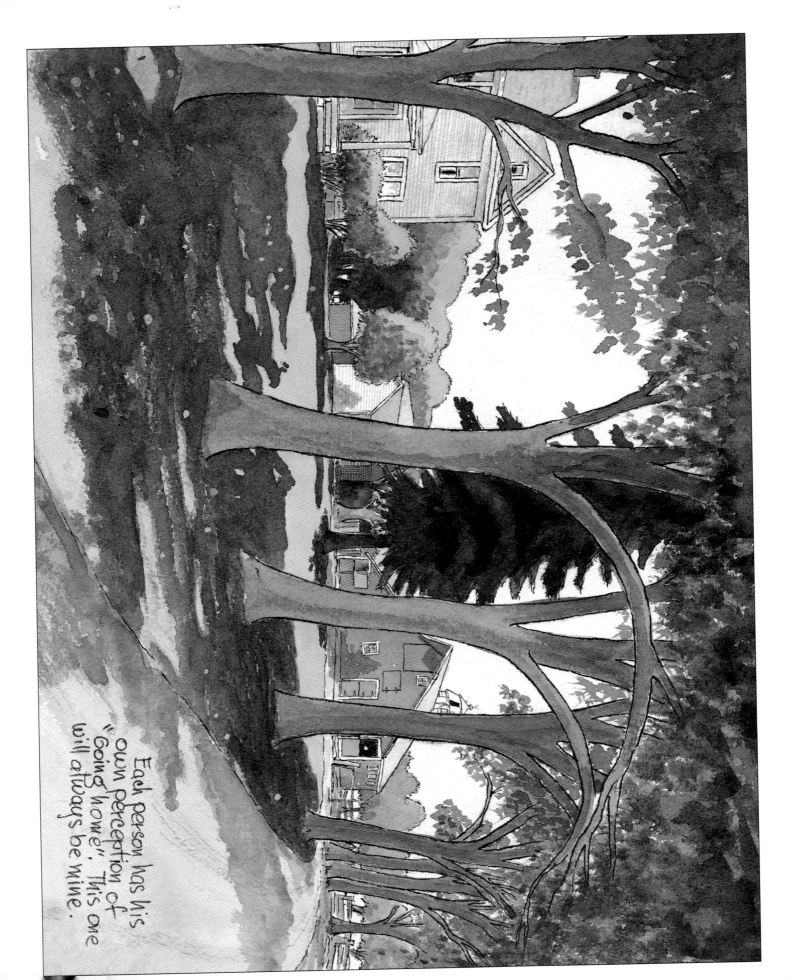

Each person has his
"own perception of
"going home". This one
will always be mine.

Thankfully, our farm, through adaptation, has managed to survive. But Artley Farm is physically not the same as it was. Dean owns the west half of the 202 acres, including the homestead plus the additional "40" across the road. Although supposedly retired, he continues to perform a labor of love in maintaining, repairing, painting, and in other ways caring for our ancestral home. My sons, Rob and Steve, each bought a portion of the east half of the original farm, and are planting trees and in other ways adding their touch to this special place.

Corn is now a minor crop, sharing space with alfalfa, organic soybeans, oats, rye, and six acres of strawberries. Also, there are two stands of cut-your-own Christmas trees.

Upon my military discharge after World War II, I hitched a ride to where the road past the farm joins Highway 3. With a duffel bag slung over my shoulder, discharge papers in my uniform pocket, and a song in my heart, I set out for home. As I came to the brow of the hill and saw our farm on the far north side of the valley, that bright January afternoon in 1946, my heart was bursting with anticipation. Soon I'd be gathering my family in my arms. I was coming home!

The years that followed saw many more changes. My grandparents died, then Dad passed away at the farm after a long illness.

After years of decline, Mom later joined Dad. All of my aunts, uncles, and several cousins are now gone.

The most devastating loss was Ginny's death in 1993. In 1998 our firstborn, Jeannie, died. Both had been very much a part of the farm.

Over the years Ginny and I and our four children—Jeannie, Robbie, Steven, and Joni—had made many pilgrimages to the farm. Even after Dad's death, Mom, with her loving spirit, drew all her family home to the farm for visits during the rest of her years there.

Some of the familiar old buildings are gone from the farm. The silo, the double corn crib, the cattle shed, the hog house, and the privy are no longer a part of the scene. But those added include the machine shed, a large hay barn, a round metal corn bin, and a sales room for strawberries (built into the old granary).

Artley Farm was and still is, to those of us surviving, together with our grandchildren and great-grandchildren, a place to come back to.

Margaret and I married in 1995. We divide our time between our Florida residence and the farm, but for as long as I am able, Artley Farm will always be where I come home to.

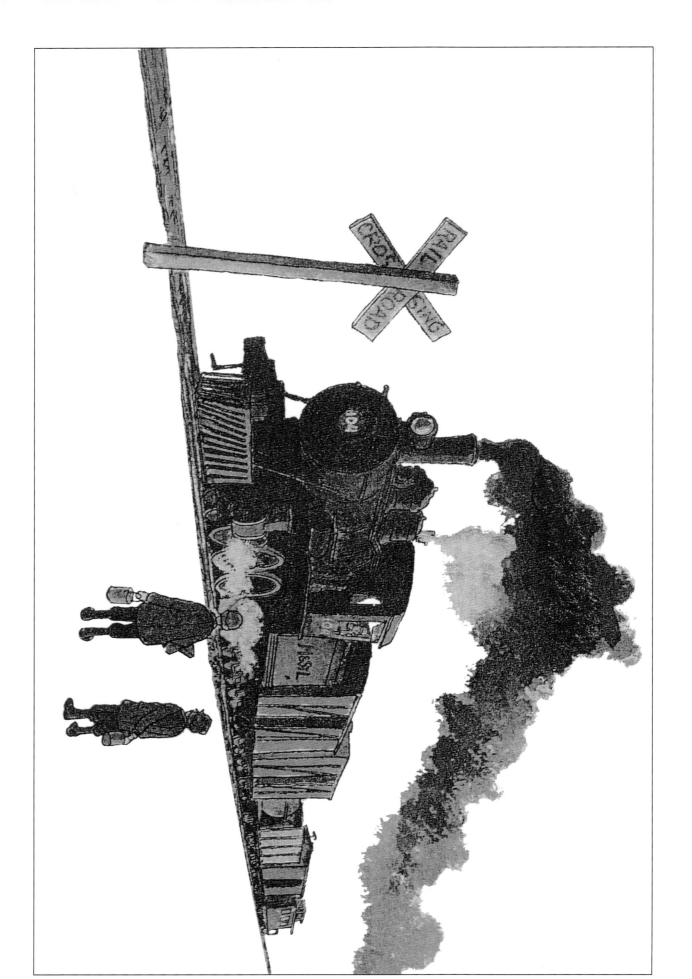